THE PHOTOGRAPHER'S GUIDE TO USING

LIGHT

THE PHOTOGRAPHER'S GUIDE TO USING
LIGHT

by Ted Schwarz and Brian Stoppee
with Thom O'Connor

Photographs by Mike Pocklington and Scott Sheffield

AMPHOTO BOOKS

an imprint of Watson-Guptill Publications/New York

First published 1996 in New York by AMPHOTO,
an imprint of Watson-Guptill Publications,
a division of VNU Business Media, Inc., 770 Broadway, New York, NY 10003
www.amphotobooks.com

Library of Congress Cataloging in Publication Data

Schwarz, Ted, 1945–
 The photographer's guide to using light.

 Includes index.
 1. Photography—Lighting. I. Stoppee, Brian.
II. O'Connor, Thom. III. Title.
TR590.S38 1986 778.7 86-22336
ISBN 0-8174-5421-7
ISBN 0-8174-5422-5 (pbk.)

About the Authors

Ted Schwarz is a professional photographer and writer, the author of more than 45 books and over 2,000 articles. He began his career as a freelance photographer at the age of 17, with such clients as the Cleveland Pops Orchestra. By the time he opened a studio, his list of clients included Standard Oil, Stouffer Foods' Restaurant Division, an IBM. Ted eventually moved into the fields of location advertising photography and editorial illustration, working for such clients as *Family Circle* and the German news publication *Stern*.

His most recent books on photography include *McGraw Hill's Handbook for Professional Photographers* and *Starting Your Own Professional Photography Business* (Focal Press). He is a regular contributor to professional photographic journals, including *The Rangefinder* magazine and *Photo District News*.

Brian Stoppee and his organization, the Stoppee Photographic Group, have been involved in photographi lighting research, design, and education since the company's inception in 1977. Brian's seminars, offered around the country, have instructed hundreds of photographers on the basics of lighting theory and application.

Mike Pocklington is a Richmond, Virginia, native who has been a professional photographer for nine years. A former advertising executive, Mike now operates his own studio in Richmond, specializing in studio still life and people photography. A partial list of his clients includes: NCR, Masonite, Best Products, Whittaker General Medical, First Colony Coffee, Miller & Rhoads, S&K Famous Brands, United Virginia Bank, the Virginia Department of Tourism, ARA Services, Smith-Bowman Distillery, Virginia Peninsula, Marval Poultry, Eskimo Pie, and a number of other advertising and design agencies.

Scott Sheffield is a dedicated photographer who specializes in creative effects, laser techniques, and other technical tours de force. Scott incorporates his background as an airbrush artist into his visual perceptions as a photographer and strives for total involvement in the creation of an image. This involvement will offer the design and construction of special equipment and sets. Listed among Scott's clients are: A H Robins, Best Products, American Filtrona, Reynolds Metals, Robertshaw Controls, the U.S. Historical Society, Alpha Audio, Stihl Chain Saws, Massey Coal, and Quinton Instruments.

Thom O'Connor is an editorial and corporate photographer of 15 years experience, who is based in New York City. In the past five years, Thom has gained an equal reputation for his writing on a variety of photographic subjects. He is the Technical and Product Editor for the *Photo District News*, a Contributing Editor to *Lens* magazine and *Lens On Campus*, a Contributing Writer to *Popular Photography* and *American Photographer*, and Editor of the Advertising Photographers of America (APA) newsletter.

Contents

PART ONE

UNDERSTANDING LIGHT

Simply stated, "available light" is the sum of all the various types of illumination shining on a scene. It may take the form of sunlight, fluorescent tubes, tungsten globes, household lamps, neon signs, even moonlight. It may also include the photographer's photoflood lighting or electronic flash, although purists insist that those forms of light are not really used in "available light photography."

Dogma aside, our feeling is that any form of light used to record an image on film should be known as "available light." Some forms, such as electronic flash, can be extensively manipulated to help achieve the photographer's vision, while other forms, particularly the sun, must be used almost without modification. But the fact that flash can be manipulated does not make it any less "available" than sunlight.

For the beginning photographer, shooting in available light seems to be only a matter of setting the camera for the correct exposure, then focusing and taking the picture. However, as the advanced photographer soon learns, available light comes in an assortment of colors and intensities that can add drama or subtlety to every subject and scene.

Even before the film is loaded into the camera, the photographer must understand that, with the exception of flat objects, the nature of photography requires that a four-dimensional situation be recorded onto a two-dimensional plane. Effective lighting in photography will help to retain and transmit the idea of the subject's height, width, depth, and—as the fourth dimension—time.

Harnessing available light to create beautiful images is a skill which, unfortunately, many photographers never learn. But it can be learned, through a combination of absorbing the technical background, then putting theory to practice in the field. In Part One, we will explain the qualities and nuances of available light, and talk about the problems associated with its use. We will briefly outline the ways in which available light can be modified, and discuss equipment that can help you generate and control your own light. In Part Two, we will apply theory to practice, illustrating how *you* can exploit light to improve your photographic imaging.

Sunlight

The sun is, of course, the most reliable source of available light used in photography. Yet sunlight is neither constant nor consistent. The angle of the sun in the sky, the presence of clouds, or the amount of pollution in the air all affect the color of sunlight. In describing the sun's color value, it's not enough merely to say the light "looks blue" or "kind of red," or "warm" or "cold." To seriously discuss available light, we need a more specific terminology, namely the Kelvin Color Temperature Scale.

The Temperature of Light

Photographers and scientists rely on the Kelvin scale to accurately measure and describe the temperature—and therefore the color—of light. Color temperature meters are available to sample light and display a reading in degrees Kelvin (°K). The higher the degree reading, the cooler and bluer the light; the lower the degree reading, the warmer and redder the light. For example, the mid-day sun shining down from a cloudless sky will register somewhere between 5,500 and 7,000 degrees Kelvin. But just after sunrise or just before sunset, the position of the sun near the horizon, combined with atmospheric conditions and pollution in the air, will all contribute to a lowering of the Kelvin temperature to a warmer 3,000 to 4,500°K.

Kelvin temperature and color film. While the Kelvin scale is used extensively in the physical sciences, its main value to photographers is as a simple, common language for describing light in relation to color film. All color emulsions, both slide and transparency, are optimized for a specific Kelvin scale rating. Daylight film is designed to record faithfully at about 5,500°K, which is about the color temperature of a subject illuminated by the noon sun. For consistency, most electronic flash units have been adjusted to deliver light bursts at about the same Kelvin temperature. On the other hand, tungsten-balanced films (confusingly referred to as "A-type," "B-type," or "T-type" films) are designed for exposure at 3,200°K, close to the color temperature of most household lamps. Even though tungsten light is much redder than daylight, T-type color film "sees" the light and records the image with a more neutral interpretation of the colors. If you use tungsten film in sunlight, your results will be much too blue. Conversely, if you shoot with a daylight-type emulsion with indoor lights, your subjects will be a decidedly yellowish-red.

AVERAGE KELVIN TEMPERATURE OF COMMON LIGHT SOURCES STRIKING A SCENE

CLEAR SKY		12,000°
HAZY SKY		9,500°
OVERCAST SKY		7,000°
ON-CAMERA ELECTRONIC FLASH		5,800°
COLOR-CORRECTED FLASH SYSTEM		5,500°
MIX OF SUN AND SKY		5,500°
CARBON ARC LAMP		5,200°
2 HOURS AFTER SUNRISE		4,000°
2 HOURS BEFORE SUNSET		4,000°
1 HOUR AFTER SUNRISE		3,500°
1 HOUR BEFORE SUNSET		3,500°
PHOTO FLOOD LAMPS		3,400°
QUARTZ LAMPS		3,200°
SUNRISE AND SUNSET		3,100°
100-WATT INCANDESCENT BULB		2,900°
75-WATT INCANDESCENT BULB		2,800°

The sun's palette of colors.

Advanced photographers often evaluate their prints and slides in relation to the sense of warmth or coldness they evoke. Obviously, a "warm scene" doesn't refer to a change in body temperature, but to a feeling aroused in the viewer. Hues of red, pink, orange, and yellow commonly convey warmth, while blue and green signal coldness.

Sunlight can impart a remarkable assortment of visible, almost tactile, levels of warmth and coldness, even during the course of a single day. If you observe an outdoor scene at daybreak, with the sun not yet above the horizon, muted blues will prevail, the greens in the grass and trees will be exaggerated, and earth tones will seem blue and subdued. Return to the same spot at noon, when sunlight is made up of roughly equal amounts of warm and cool colors, and the scene will contain a fairly neutral color balance, with no exaggerated richness or depth. Check again just before sunset, when warm colors predominate, and the sun will wash the scene with glowing, romantic rays of yellow, red, and gold. Although the physical components of the colors in the scene haven't changed during the day, the color of the available daylight *has* changed, altering your perception of the landscape. Experienced photographers are aware of the palette of hues to be found in daylight, and they use color to enhance their photographic images.

The Gray Card

When reduced to monotones, life's visuals are, on the average, seen at a value of 18-percent gray. This is known as *neutral density*.

The reflective light meter in a 35mm SLR is calibrated to "see" all situations as if they were 18-percent gray. In most cases, the meter in your camera will be correct, but the purchase of a *gray card* at your local photo supply store will not only ensure your meter's calibration, it will also allow you to make exposure decisions for those times when your subject should *not* be rendered at the 18-percent gray value.

A gray card is simply a small piece of cardboard that reflects 18-percent of the light that strikes its surface, while absorbing the rest. The other side of the card will reflect 90-percent of the light that strikes it, absorbing the other 10-percent. This surface represents white.

On the opposite end of the spectrum is black, which absorbs the majority of light and reflects next to none.

Color, Texture, and Tone. The purpose of using a gray card is to understand how a subject can be broken down into varying degrees of exposure values, all representing the different degrees of light reflectance. In theory, all of these values, when seen

A standard photographic gray card.

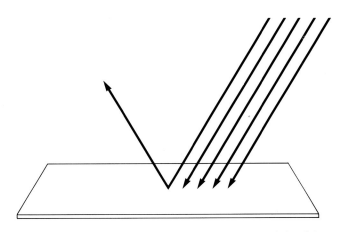

Light falling on a gray card reflects only 18-percent of that light.

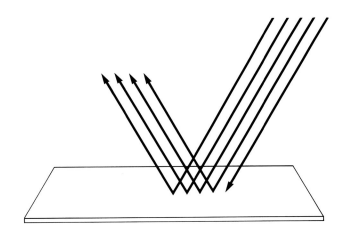

The same amount of light falling on a white card reflects 90-percent of the light.

The color of light changes in both quality and mood, depending on the time of day. These photographs dramatically demonstrate the effect of these changes, even in the most average setting. The first photograph of this skyscraper *(top)* was taken just after daybreak. Notice the cool, blue tone of the scene, particularly in the whites. The green grass and trees also take on an exaggerated blue cast.

At noon *(middle)*, the same setting is fairly neutral and flat, with no contrast offered by the overhead light. The colors are bright, and average in tone, but the scene has no particular interest in the quality of the lighting.

Sunset offers the most dramatic rendering of the subject *(bottom)*, with the warm colors of the evening sun adding an orange flow to the photograph.

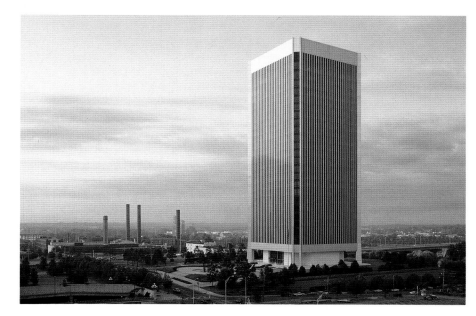

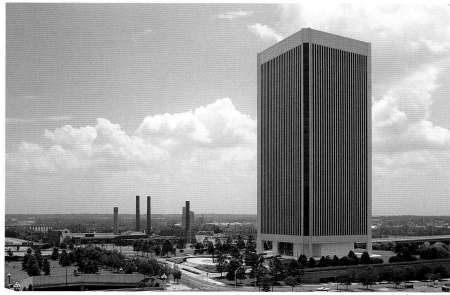

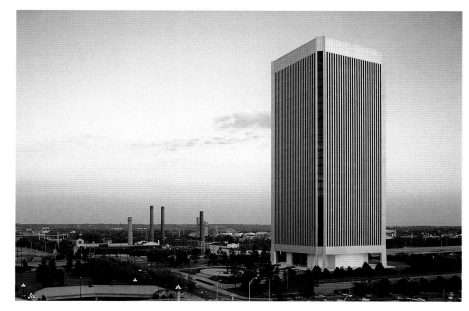

in black and white, can be rendered in direct comparison to the percentages of a standard gray scale, representing the full spectrum between white and black.

When working in color, these values correspond to the gray scale, but are discussed in terms of their light or dark values.

Therefore, tone and color work together. Each patch on a gray scale reflects and absorbs a different amount of light. The lightest has the greatest degree of reflectivity; the darkest has the least. The same is true of color. A single pigment of yellow has a corresponding tone on the gray scale. The lightest tone of that pigment reflects the most light, while the darkest tone has the greatest absorption.

A glossy surface reflects more light than a dull one and two identically colored subjects can be perceived as having different colors if their finishes are not the same. A shiny, high-gloss vase will appear to have rich tones and color values, while a vase of the same color with a matte finish will appear more subdued. This is because light striking a coarsely textured surface will become diffused. The more uneven the surface of the subject, the more scattered the rays become. Less light is reflected in the direction of the viewer and the object's full tonality is not realized.

"Super White" and Color Reflections. All surfaces reflect and absorb light to one degree or another—even the blackest surfaces on earth.

Various fabrics and papers sold for use as photographic backgrounds are named *Super White*. Some of these surfaces are bleached to be more "colorless" than average white materials; others will add a false tint of blue to eliminate the inherent yellow qualities. No matter what degree of "whiteness" exists, some of the light striking the surface will be absorbed— there are no absolutes. The majority of the light reflected will contain the same yellow or blue properties that are present in the surface. As such, the "super white" is not as super as its name implies.

Equally, light falling on an intensely colored surface will reflect light of that same color. For example, the closer a model's face is to green grass in direct sunlight, the greater the intensity of the green reflections on the model's chin and neck.

Working with the angle and direction of sunlight

The broader and more diffused the light falling on a subject, the softer the shadows. Conversely, the more narrowly concentrated the light, the deeper and darker the shadows. Although the sun is tremendously large, and blankets the earth with light, it's really not a diffused source of available light if used in portraiture, unless the model sits in the shade or poses outdoors on an overcast day. Rather, in a clear sky, the sun is an intense "point source" light, a giant photoflood bulb in the sky. If you've ever followed the simplistic advice on outdoor shooting to "Stand facing your subject with the sun over your left shoulder," you've probably been rewarded with less-than-pleasing portraits of people squinting uncomfortably toward the sun, features grotesquely exaggerated by strong dark shadows under their noses and in their eye sockets. The effect is similar to aiming an undiffused photoflood bulb, housed in a shiny reflector, directly at the subject from a distance of about eight feet.

Advanced photographers are aware of the sun's ability to create shadows and, depending upon the subject, will either modify the light or use the shadows to highlight elements of the subject. For example, when the sun is in mid arc, the weathered wooden side of a barn facing the sun will photograph as a grainy, if somewhat flat, wood surface. But with the sun lower to the horizon, at an angle of 70° or 80° to the face of the siding, the wood will explode with bold highlights and deep, dramatically textured shadows. Unfortunately, the same lighting that helps improve this type of still-life can make the human face look excessively lined and distorted. For that reason, controlling sunlight becomes an important skill to master.

Modifying sunlight

When making portraits, you may choose to shoot outdoors even though the available sunlight is too harsh for pleasing results. You might want to pose your subject against a breathtaking landscape, taking advantage of the variety of background colors that nature offers. Despite the harsh sun, you can still shoot outdoors, modifying the light by using the following techniques.

Block the sun. If your model is squinting into a brilliant sun, block the direct rays falling on your subject's face by using a black umbrella or a sheet of posterboard. The level of illumination on the model will drop, but the remaining light from the sky will be softer and more flattering. Large, flat, rectangular umbrellas—"gobos" or "flags" as they are called by pro photographers—are available from professional camera dealers. For shooting on a budget, use your own trusty umbrella, or fashion a gobo using a sheet of stiff cardboard.

Fill in the shadows. By placing a large, reflective white surface next to your model, you can bounce sunlight from the side opposite the sun, thereby lightening, or "filling" the shadows. For a "fill card," use a piece of neutral white cloth stapled to cardboard, a white posterboard, or sheet of newspaper held next to the subject, out of the camera's field of view. Again, professional camera shops sell white reflecting umbrellas for just this purpose.

Blocking bright sunlight results in more flattering illumination of your subject. While the overall light level may drop, the result will be softer and more even. This technique will also prevent your subject from squinting.

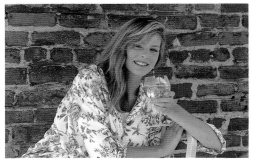

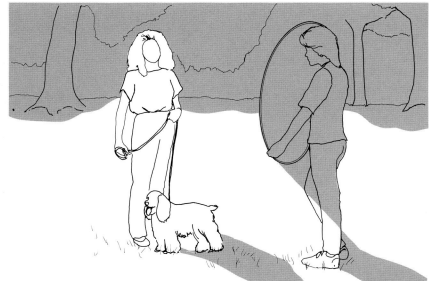

Fill in the shadows by placing a large white reflector next to your subject. Bouncing extra light into the side opposite the sun will give you more even illumination and soften the effect of a strong directional light.

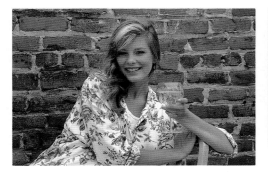

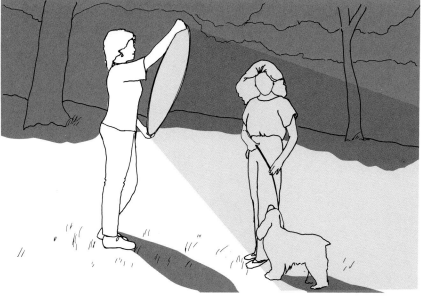

Diffusing the sunlight with sheer white fabric placed between the subject and the light source gives soft, even illumination, without harsh shadows.

Colored fabric or cardboard will bounce colored light into the shadows, an effect you may not find desirable when using color films. Also, while a highly reflective surface, such as aluminum foil, will bounce more light, the light will have more "bite" and will not be as soft as a white fill card.

Diffuse the light. When shooting outdoors, motion picture companies are seldom without their "silks," large translucent diffusing panels that can be quickly erected between the sun and the actors to produce a soft, even light without harsh shadows. On a smaller scale, still photographers can also use diffusion panels or "scrims" to tame the sun. Thin, white muslin fabric is a good choice for this job, as is white ripstop nylon, and the material can be attached to a homemade wooden frame. For larger panels, many photographers construct lightweight frames by gluing together lengths of plastic PVC water pipe, then covering the frame with a white plastic shower curtain. Professional camera dealers also sell a wide variety of photographic umbrellas and folding panels for use as scrims.

A variety of materials are manufactured to help photographers control the light falling on a subject. Whether white or colored, flat or shiny, each will give you the final choice of how your subject appears.

A SUNLIGHT CHECKLIST

In order to understand the effect of sunlight on a scene or a model, you need to attentively study the quality of the available light *before* you start shooting. In that way, you can compare your finished photographs with your initial impressions of the scene. The following checklist can be used as a guide.

1. Is the sunlight cool (early morning), neutral (midday), or warm (late afternoon)? How will the color of the light affect your subject?

2. Is the color "personality" of the film you wish to use right for the subject? How will the film's warm, cool, or neutral color bias affect what you are trying to convey?

3. When making portraits, pay special attention to how the height and angle of the sun throws shadows around your subject's nose, mouth, eyes, and hair. If the shadows are too harsh, can you move your subject, diffuse the sun's light, or wait for a better time of day to make the shots?

4. In scenic photography, will the color and angle of the sun enhance or degrade the image? A field of waving wheat shot just before sunrise will be recorded as chilly blue, while the same field photographed in the late afternoon will be positively golden. And a snow scene that records warm at sunset will appear pristine white at midday.

Personalities of color slide films

Each manufacturer of color emulsion has a slightly different sense of how color film should record a scene. One maker may insist on vibrant, pulsating blues and greens, while another promotes subtle pastel shades. Even two films from the same maker will exhibit different color rendering, as proved by Eastman Kodak's popular slide films, Kodachrome and Ektachrome, each of which produces different results. Kodachrome responds strongly to reds and oranges, producing richly saturated colors, while Ektachrome delivers deeper blues and greens. Other films also have unique flavors. Fujichrome, made by Fuji Photo Film, is generally considered a warm film with especially vibrant green tones when compared to Ektachrome, while Agfachrome, from Agfa, is regarded as a neutral film.

When combined with the ever-changing colors of sunlight, the choice of a particular color film personality can dramatically alter the photographic feeling of the scene. If you were to use Ektachrome to photograph a model in the blue-toned light before the morning sun breaks over the horizon, the model's skin would appear forbidingly cold in the slide. But if you were to use Kodachrome in the same situation to downplay the blue, the model's skin will display a warmer, healthier tone.

Shooting for prints

Slide films are particularly useful for faithfully recording a photographer's visions in color, even though each film adds its own personality. Color *print* films also have personalities, although these are much less apparent than those of slide films. The biggest difference between prints and slides is the additional darkroom step required to turn a negative into a finished print. The rendering of colors in a print then becomes, in part, the result of a lab technician's personal bias—or a computer's inhuman judgment—about which combination of colors looks "right." A serious photographer using color negative film will therefore work closely with a color darkroom technician to produce prints that reflect the photographer's personal interpretation of the scene.

Kodachrome 64

Fujichrome 50

Bracketing for creative color control

As we have discussed earlier, many advanced photographers prefer to use color slide materials because, unlike print film, changes in exposure, and adjustments in the film developing routine often cause dramatically pleasing—if unexpected—changes to the colors. Depending upon the exposure, a scenic view photographed on slide film may render the sky just plain blue, rich blue, or deep royal blue. A lightly tanned model can be made to look almost toast-brown on slide film with the judicious use of underexposure. At the other extreme, *over-exposure* of color slide films can wash out the colors, producing a predominantly pastel rendering.

It's often hard to predict or previsualize the results of over- or under-exposing color transparency film, and for that reason, many photographers choose to "bracket" their shots. An exposure bracket usually includes three to five frames taken of the same subject, all recorded with slightly different apertures. A three-shot bracket works like this: The first shot is made with the camera set at what the meter—and

your best judgment—indicate will be the correct exposure. Then close down the aperture by one half-stop (half the distance between two full aperture points as marked on your lens) for the second shot. Finally, open the aperture by half a stop from your starting point. The result will be three exposures, each a half-stop apart. For a longer bracket, add yet another half-stop exposure above and below your optimum setting. The processed film will reveal interesting—and often startling—changes in color, saturation, and shadow density.

There is one obvious drawback to bracketing: your subject must remain stationary for a few seconds to record the same position on three or five frames of film. Bracketing a Grand Canyon scene is easy, but following, focusing, and bracketing shots of an active three-year-old is not for the faint of heart. This is the reason veteran photographers use their bracketing sparingly, on subjects and scenes that will benefit from the technique.

Bracketing may also help in situations where there seems to be no clear-cut "best exposure" for a

Ektachrome 64

Agfachrome 50

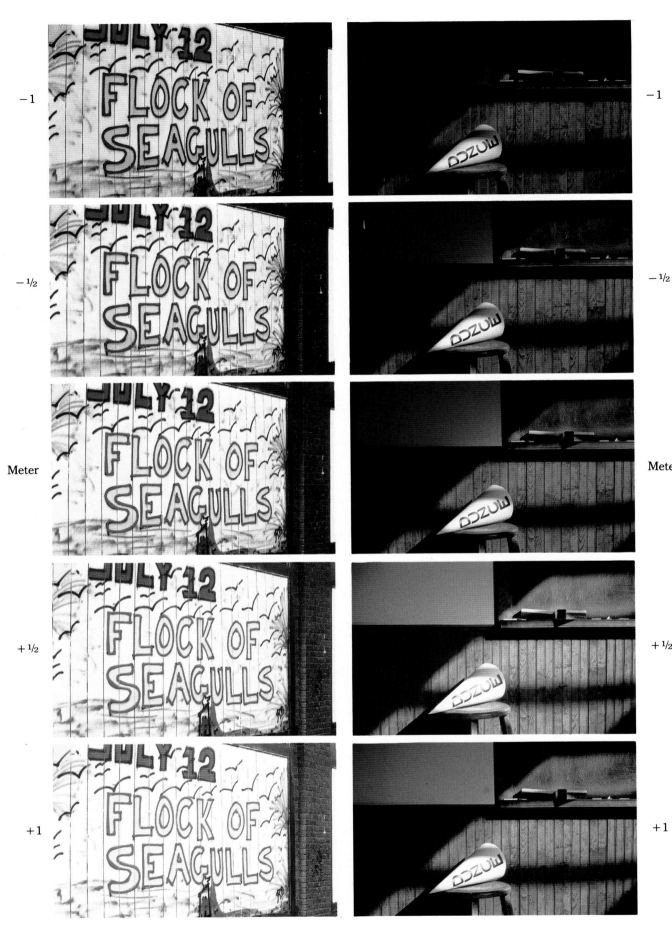

−1

−1

−½

−½

Meter

Meter

+½

+½

+1

+1

scene. A combination of strong and weak lighting sources often creates brilliant bright spots surrounded by deep shadows. Your model might be seated indoors, illuminated by the tungsten light from a reading lamp. Early-afternoon sun streams through a nearby window, brightly highlighting the bookshelves behind the model. Basing your exposure on the strong light from the sun will result in underexposing the model. Exposing for the lamp light will render the model correctly, but will wash out the bright bookshelves. A number of solutions—including bracketing—are possible. You could cut down the intensity of the sunlight with a drawing of the drape, pulling down a window shade, or using a translucent scrim to cut down the direct sunlight. You could increase the amount of tungsten light by exchanging the household bulb for a higher wattage photoflood bulb. (Take care not to leave a photoflood burning in a household lamp for an extended period, as most table and floor lamps are not designed for the high current consumption and heat output of photoflood bulbs.)

You might also consider shifting your subject to a different location, or waiting until the sun moves to another position in the sky. All of these alternatives work, but they require added lighting equipment, a change of location, or additional time.

Bracketing offers a quick and easy alternative, which assures you of at least one acceptable photograph, and which may also produce interesting alternate shots. In this situation, simply meter for the light falling on your subject, then shoot as you adjust camera aperture and/or shutter speeds in half-stop brackets around the "correct" exposure.

The reciprocity gremlin

When shooting with extended exposure times—typically one second or longer—you need to make adjustments to compensate for the "film reciprocity failure effect," in which emulsions record differently at very slow speeds than they would at normal exposure times. Basically, as the time the film emulsion is exposed to light *increases,* the sensitivity of the emulsion *decreases.* In addition, the color balance of the film may change. (The reciprocity effect also comes into play with very *fast* exposures of $1/10,000$ sec. or less, but photography at those dizzying speeds is used almost exclusively for scientific applications.)

In practice, the reciprocity effect can result in underexposure of the image and a color shift. If you are recording a moonlit beach at night with ISO 400-speed film, your light meter might indicate a ten-second exposure. But with extended exposure, your film behaves as though it were rated at a slower ISO 150. The resulting images will be underexposed and the colors will shift slightly toward green. To compensate, you need to increase your exposure by $1\frac{1}{2}$ stops, either by opening your lens a stop-and-a-half, or by increasing exposure to 30 seconds (10 seconds doubled equals 20 seconds, plus half of 20 seconds equals 30 seconds). And you will need to use a magenta filter over your lens to correct for the slight green shift.

Recommendations on reciprocity exposure compensation and color filtration are generally available in the data sheet packed with each box of film, and detailed information can be obtained from the film manufacturers.

Bracketing one-stop over or under the meter's reading can be of great help in reaching the proper exposure. This technique is especially useful when photographing subjects that depend on proper color saturation *(opposite page, left),* or when the extreme range of light values in a scene make exact metering difficult *(opposite page, right).*

Existing Light

Any light, other than the sun, that naturally falls on a subject or scene and can be used for photography should be considered existing or, as more commonly termed, available light. Under that heading we can include street lights, fluorescent tubes, neon signs, gas lamps, candles, tungsten globes, and hundreds of other light sources, including moonlight. However, there are a few exceptions to the definition. Electronic flash, photofloods, and similar professional equipment, while certainly sources of artificial light, are not normally "available" without preplanning by the photographer. So for that reason, we will discuss those sources of light in the next chapter, dealing here only with the light to be found falling on a scene or subject.

As with photography in sunlight, there is more to artificial available light shooting than just aim-focus-shoot. To produce high-quality images, you must understand the unique characteristics of various types of artificial light.

Indoor Lighting

The most common sources of indoor illumination are tungsten bulbs and fluorescent tubes. Tungsten incandescent bulbs, referred to by pro photographers as "hot lights" because of their high operating temperatures, come in an abundant variety of sizes, from 7½- to 250-watts. The wattage is a rough indicator of brightness, although internal reflectors and bulb surface coatings can greatly affect the light output of different bulbs rated at the same wattage. For photography, higher capacity photofloods and quartz lamps, rated at 500 to 1,000 watts, are often used.

Regardless of their size, most tungsten bulbs deliver light at a color temperature somewhere between 2,800° and 3,400° Kelvin. The exception is a special type of blue-coated photoflood lamp, rated at 5,000° K, and used in lighting interiors for motion picture filming. However, these bulbs are not often used in studio still photography.

Mercury- and sodium-vapor lights. Many large interior spaces, such as auditoriums and sports centers, are illuminated by high-intensity, mercury-vapor lamps, which emit strong rays in the green/yellow band, or by high-pressure sodium lamps, which emit green, yellow, and orange rays. Both lamps will distort the colors recorded on film, so when shooting under those conditions, advanced photographers often take the precaution of shooting a test roll of transparency film beforehand and then adding filtration based on the test results. If time restrictions prevent pretesting, the light from sodium and mercury vapor lamps can be color-balanced somewhat by using special filters such as the Singh Ray SR-L15, which is formulated for use under sodium vapor lamps, or the Singh Ray Type B filter, which can be teamed with tungsten film for shooting with mercury-vapor lamps.

Firelight and candles. Recently developed high-speed color films, with ISO ratings of 1,000 to 1,600, have made the tough job of recording a candle- or firelit scene an easier task. The light from candles or fires, at about 2,700° Kelvin, records as a warm, romantic glow on tungsten film, and as an exaggerated red-orange-gold on daylight film.

Night shooting. Making photographs outdoors at night entails a number of compromises. Seldom are available light sources all of the same color type. The illumination from neon signs is often mixed with the spill from fluorescent tubes found in store window displays. Mix in the light from car and truck headlights, plus the mercury-or sodium-vapor street lamps, and the light computation can be quite complex. Generally, it's best to decide how to record the main subject or model with a minimum of filtration, then let the other sources of illumination fall where they may on the color spectrum.

If they can be isolated or are shot by themselves, car lights, street lamps, and "hot light" window displays are best photographed on tungsten film. Subjects lit primarily by neon signs, carbon-arc spotlights, or fluorescent tubes should be recorded on daylight-type film. But if you are primarily interested in recording neon signs, and don't care about the other illumination in the scene, try using both tungsten and daylight films to produce interesting and varied results. As always, it pays to experiment using different films and filters under mixed outdoor lighting *before* shooting an important picture.

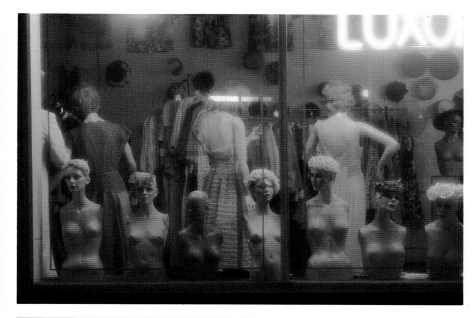

After dark, city streets provide a photographer with endless studies of artificial light sources. Night scenes can incorporate fluorescent, tungsten, and neon sources, each with their own Kelvin temperature and color spectrum. Creative choice of film can help to render a night scene in any number of ways. A subject bathed in tungsten light will appear warm and inviting when shot on Daylight-balanced film *(top)*. The same scene will take on a cold and harsher look when photographed with Tungsten-balanced film *(middle)*. The warm illumination of the scene will become somewhat neutralized, and fluorescent lighting will shift from cool cyan to cold, deep green.

In both of these photographs, the photographer made use of high-speed film to capture the window reflections and further enhance the atmosphere of the scene. Photographers cannot only make use of the grainier quality of these films, but the wider exposure latitudes of films with ISO ratings from 200 to 1600 can pull details out of shadows and intensify highlights.

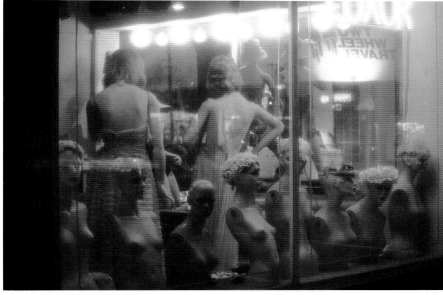

This warm, romantic image was created with only the light of a candle and the capabilities of Ektachrome pushed to ISO 1600. This special-application, professional daylight emulsion offers a full exposure range and wide color spectrum. Even with the limitations of candlelight, the subject appears fully illuminated.

The larger grain softens the effect by deleting much of the finer detail. The highlights on the subject face seem to wash away and assist in focusing the viewer's attention on the model.

Determining Exposure

Regardless of the quality of available light, or the type of film used, a poorly exposed photograph is not usually satisfying. Serious photographers recognize the need for meticulous attention to correct exposure, and they rely on a number of fundamental lighting theories along with a selection of light-sampling devices to improve the quality of their work. While there is a light meter available to suit almost any need, the photographer should understand the basic principles of light relationships and how they affect exposure.

Photographing Flat Planes and Contours

In order to begin to use light effectively, the photographer must realize the impact of the angle of a light source and its affect on the values of each area of a given subject.

The Angle of Incidence. Faced with the prospect of photographing a flat subject behind a plate of glass, the untrained photographer will probably be frustrated in his attempt to take a successful picture. The subject may well be obscured by reflections of the light source from the glass covering. If the camera is perpendicular to the flat surface and the source of illumination is directly above the camera, chances are good that the result will be a picture of a light source reflected in glass.

However, in a controlled studio environment such an assignment becomes much easier. Moving the light source to the right-hand side of the camera at about a 45-degree angle and adding a second, identical light source at an equal distance to the left of the camera will eliminate this problem. This lighting setup is based on the principle of the *angle of inci-*

dence, in which the incident light strikes the surface at 45 degrees of the camera's axis and reflects its light at an equal and opposite angle. With a two-light setup, the angle of incidence equals the *angle of reflectance* and, since no light is reflected on the camera's axis, the camera sees no reflections.

Shooting for Three-Dimensional Contrast

When photographing a one-dimensional object, the photographer's aim is to retain the flatness of the subject. Of course, the majority of a photographer's work will be dealing with three-dimensional subjects and such situations offer a variety of lighting options. Working with light that is striking a contoured subject is more complex than when shooting a flat object, but the tools used and basic principles applied remain the same.

Using the human face as an example, we will be working with a subject that provides an almost infinite variety of planes and surfaces. The basic face comes with a nose, a chin, lips, and eye sockets—all representing a complete range of contours.

Let's go back to our original flat surface and say that it is a piece of shiny Plexiglas with an overall value of 18-percent gray. The surface, evenly illuminated by two identical light sources equidistant from the camera, is referred to as the *key*. Using a light meter, we establish that an exposure of *f*/11 is required to render the flat surface on film with the same 18-percent gray value.

Now, if we replace the piece of Plexiglas with a face, the same lighting setup would produce a fairly evenly lit photograph. But unlike the flat surface, the face with all its surfaces, would have a vast array of highlights and shadows.

When photographing flat art, the photographer must rely on understanding the *angle of incidence.* Two lights of equal power are placed equidistant from camera and subject, balancing each other's reflections.

Using a single light source on a flat surface produces a "hot spot" of reflection, known as a *specular highlight.*

Light Ratios Simplified. Had we used the single light source on the flat surface, it would have produced a "hot spot" of reflection, known as a *specular highlight.* This represents a mirror image of the light source and is in contrast with the rest of the key value. And just as key value can be measured and assigned an *f*-stop for the proper exposure, so can the highlights and shadows.

The key has been determined to have an exposure value of *f*/11. There is a single light source to the immediate right of the camera with its center approximately one-and-a-half feet above the subject, a young woman's face. On that face exists at least one surface that is the obvious "norm," or key. We have assigned that section of the face a value of *f*/11, or, for the purposes of establishing a ratio, a value of 1.

Since that light source is to the right of the subject, a shadow will naturally fall to the left. If our meter focused its attention only on the shadow, it would produce a reading of *f*/8. If this were a picture about the shadow area and we wanted the shadow to read as the key, we would need to open up one more stop from *f*/11. But this isn't a picture about the shadow area, it is a picture about a norm where a shadow exists. The difference between the key and the shadow is said to be in a ratio of 1:2 (1 being the value we assigned to the key and 2 for the shadow area, since its value is one stop greater than the key).

A third ratio could be assigned to the specular highlight, the shiny spot on the face that mirrors the light source. If that specular light were measured to have a value of *f*/16—one stop less than *f*/11—the contrast ratio between the key and the highlight would be 2:1. The ratio between the specular highlight, the key, and the shadow would then be 2:1:2. A more intense specular highlight may read *f*/22, which would create an overall reaction of 4:1:2.

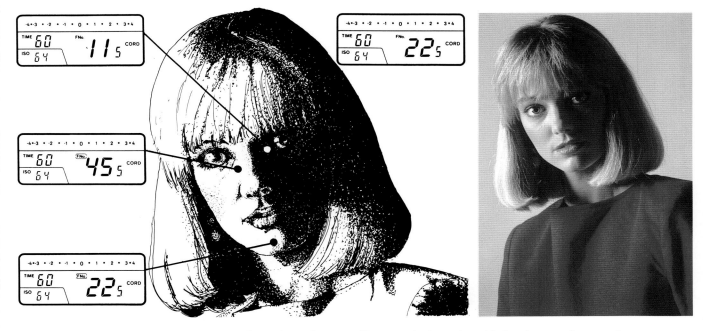

If a light meter were able to "zero-in" on specific portions of a subject's face, we might see readings similar to those illustrated here. Separate readings would indicate the light ratios between the norm (*f*/22.5), the shadow (*f*/11.5), and the highlight (*f*/45.5).

However, in the real world, the photographer must be able to understand these ratios and make a decision as to which exposure setting will result in the desired effect.

Creating a Highlight/Controlling a Shadow.
Just as the main light source created a highlight in the above example, a secondary light source could be used to control the shadow. In the controlled environment of the studio, many variations can be used to create and control shadows and highlights, but life provides only one natural light source: the sun. Nature additionally provides many secondary light sources in the form of giant reflectors, which bounce light back onto the subject. These include grass, snow, sand, and such man-made structures as white walls. In addition, standard photographic reflectors can be used.

Metering in the Real World
It is neither practical nor advisable to subject a model to the long series of spot meter readings described above. In fact, most photographers examine the light that is to fall on the subject before the model arrives on the set. "Actual" metering can be a quick and simple exercise, which allows the photographer to feel comfortable in selecting shutter speeds and lens apertures after evaluating the data from the meter.

The illustration of the model's face demonstrates the practical application of the theory of light's affect on a three-dimensional subject. The light reflected from the model's chin is the norm, or key value, of the face. It best depicts the skin tone, pigment, and surface finish and texture. If a light meter could be focused on that particular area of the face, it would give a recommendation of *f*/22.5.

The most dense shadow on the face is to the right of the model's upper nose. If we were to take a meter reading of this area of the face, the meter would suggest opening up four stops, to *f*/11.5, to record this shadow as the norm.

When shooting in complex lighting situations, the photographer should make use of the wide variety of sophisticated light meters available, rather than relying on the in-camera system.

The hottest spot on the model's face is the specular highlight on the left side of her nose. A meter reading here would determine an exposure of *f*/45.5 for the norm, or two stops from our original meter reading. Combining the three readings, we arrive at a highlight to norm to shadow ratio of 4:1:4.

Obviously in a studio situation we have set up our lights to give the desired ratio of balanced highlights and shadows. In the above example, the final exposure would still be *f*/22.5. However, working out of doors, or in available light situations where the relationship between subject and light source is beyond our control, an understanding of these ratios is invaluable in arriving at an exposure that will produce the desired effect.

Light meters
The most-used light measuring instrument is, naturally, the meter contained within the camera. For the vast majority of lighting conditions, the built-in meter does an excellent job of reading, averaging, and interpreting the amount and pattern of illumination passing through the lens to the film. In autoexposure cameras, built-in metering circuitry offers the additional advantage of controlling the shutter and/or lens aperture settings.

But when shooting in complex lighting situations, many photographers require the added information an auxiliary meter can provide. Some of the most popular meters are as follows:

Incident/reflected light meters. The workhorses of non-camera metering, most hand-held units include a diffusing dome which can be placed over the meter's light-sensing electronic eye. The unit can then be changed from a reflective mode, which reads light

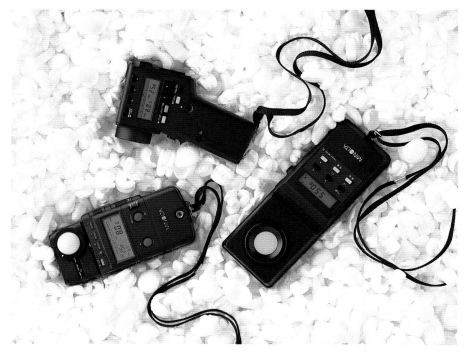

reflected from the subject, to an incident mode, which reads and averages all the light passing through the diffusion dome.

The incident light meter is useful when measuring extremes of brightness and darkness, which can fool a reflective meter. You might want to shoot a model framed against a white-sand beach on a brilliantly lit summer day. A reflective meter aimed at the subject will read a portion of the brightly lit beach and indicate a camera setting that will produce middle-toned sand but underexpose the model's face. An incident light meter reads the level of illumination falling on the scene, ignoring the bright highlights and dark shadows. The result will be a reasonably exposed photograph of the model on a strip of bright sand.

Although all in-camera meters are of the reflective type, screw-in and flip-down diffusion domes are available for attachment to the lens, thereby converting the camera into a somewhat effective incident meter.

Flash meters. These meters are designed for capturing and reading the fast burst of light (up to 1/2000th sec.) pumped from a studio electronic flash power pack. They often include multiple light-source modes, which measure both the flash illumination and the available light in a scene, then combine both readings to display the correct exposure value number or *f*/stop.

The light from a flash differs from normal light in that it affects film exposure both in terms of intensity and duration. Since the duration of normal light is continuous, a conventional exposure meter measures only the intensity of the light. A flash meter, on the other hand, is designed to measure the duration of the burst of light as well as its intensity.

A good flash meter performs as many of the photographer's light-measuring needs as possible. A meter's ambient-light measuring mode is for reading continuous light conditions. This information becomes essential when the power of the flash illumination must be balanced in relationship to the intensity of the existing room light or daylight. It additionally allows the meter to fulfill the duties of an incident/reflected light meter with accuracy to 1/10th of an *f*-stop.

When the flash meter is attached to a studio flash system's power pack through a connecting PC cord, the flashes may be fired with a button on the meter. The results immediately appear on the meter's data panel. Additionally, the photographer may "collect" a series of cumulative bursts of the flash and determine the required exposure setting. With each burst, the meter totals and displays the cumulative lighting value, along with the aperture indication for proper exposure.

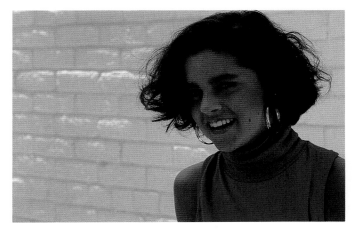

Using a reflective light meter in a situation such as this can result in underexposure of the subject's face. The meter will read a portion of the light reflecting off the white wall, and include it in the recommended exposure.

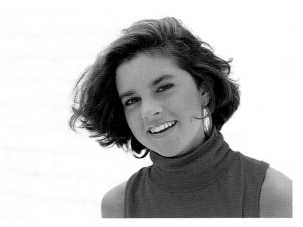

An incident light meter, used in the same situation, will read only the light falling on the subject's face, and ignore the highlights and shadows.

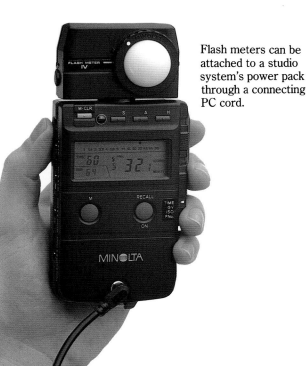

Flash meters can be attached to a studio system's power pack through a connecting PC cord.

Spot meters. These read the light reflected from a small section of a scene, or from a selected area of a model's face or body. Spot meters use optical systems similar to those found in telephoto lenses, which permit making pinpoint light readings even when the subject is a considerable distance from the photographer. Spot meters are particularly useful for determining light levels in spotlit indoor situations, where an averaging meter would read the expanse of black background surrounding the spotlit subject, then conclude that more exposure was called for than was really necessary.

Color temperature meters. As mentioned previously, color temperature meters handle the difficult job of determining the color output of fluorescent and tungsten bulbs. Many are capable of reading and digesting color information from a variety of "mixed lighting" sources falling on a scene, then providing the photographer with recommendations for filters that will produce the best overall color balance.

Other types of meters. Hand-held meters that are part of a metering "system" are useful if you often find yourself shooting under unusual lighting conditions. Such systems include a variety of attachable heads, cables, and pods, which serve to convert the standard reflecting/incident meter into a spot meter, a flash meter, or even a darkroom printing meter.

Specialized metering functions are available with a highly sensitive receptor for reflected light measurement. A *spot probe* attachment permits direct, accurate measurement of actual brightness in situations where precise metering is not normally possible. An excellent example is measuring light from the film plane of a view camera. This eliminates the need for exposure corrections and calculations due to bellows extensions.

A spot probe attachment provides an accurate reading of brightness where precise metering is not possible, such as measuring the light from the film plane of a view camera.

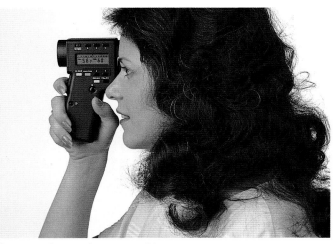

Spot meters measure the light reflected from a small portion of a scene or subject, using an optional system similar to those found in telephoto lenses.

COMMONLY USED COLOR FILTERS AND FILTER FACTORS

FILM	FILTER	LIGHTING USED	FILTER FACTOR
Daylight	80A	3,200° K lamps	2
Converts daylight film for use with quartz lamps			
Daylight	80B	3,400° K lamps	$1^{2/3}$
Converts daylight film for use with photoflood lamps			
Tungsten	82C	Household lamps	$2/3$
Provides slightly cooler results when using household lamps			
Tungsten	85B	Daylight	$2/3$
Converts tungsten type-B film for use in daylight			
Tungsten	FLB	Fluorescent	1
Helps eliminate green cast when using fluorescent light			
Daylight	FLD	Fluorescent	1
Helps eliminate green cast when using fluorescent light			

Films to Use With Artificial Lights

Tungsten-type slide films are color balanced to record optimally at 3,200°K, so photographs made indoors on tungsten film with common household lighting will appear neutral to slightly warm in color. In much the same way that the human eye and brain make corrections for the color of indoor lighting, tungsten films "see" colors in a way that is pleasing to the eye.

Dealing with the light from fluorescent tubes is a decidedly more tricky business. Most fluorescent lights have a limited color range, with some types emitting unbalanced spikes of light within a narrow green band, others leaning toward red. The human eye and brain interpret the various component colors as normally balanced light, but color films can make no such adjustment, which is why slides and prints often display a tell-tale green cast, the mark of fluorescent-light shooting. The notable exception in fluorescent lighting is the "full-spectrum" tube, which emits a wider, more balanced light, and which gives acceptable results with color film.

Unless you are sure that only full-spectrum tubes are installed in the fluorescent fixtures used to light your shooting, you'll be faced with the difficult job of correcting the available light to match your film. To help determine the type of filtration needed, many professional photographers use color temperature meters, which sample the output from a light source and indicate the color composition and Kelvin temperature. The photographer can then install appropriate color correction gels or filters over the lens.

A less critical—and less expensive—approach to fluorescent light correction is the use of one of a variety of filters (commonly designated "FLD" or "FLT") that are available from most camera dealers. These fluorescent filters are available for both daylight- and tungsten-balanced film, and provide acceptable color correction with a minimum of fuss.

Often, daylight film will be pressed into service for shooting under tungsten lighting. The photographer might wish to take advantage of the higher film speeds available with daylight emulsions, or might simply wish not to change films or cameras when the action moves indoors. An "80A" or "80B" filter can quickly be mounted on the lens to balance daylight film for use with tungsten lighting.

As with most things photographic, the use of filters involves trade-offs. Every color-correction filter cuts down on the amount of light passing through to the lens and consequently, a longer exposure time or a wider aperture (expressed in terms of a "filter factor") will be required when shooting with filters. In addition, every piece of glass, gelatin, or plastic filter material placed in front of a lens will slightly degrade the image, which makes many professional photographers adhere to the rule "Where possible, use no filter; when necessary, one filter is always better than two."

LB LIGHT BALANCING INDEX

LB+	AMBER	+EV	LB−	BLUE	+EV
+10	81	1/3	−10	82	1/3
+18	81A	1/3	−18	82A	1/3
+27	81B	1/3	−32	82B	2/3
+35	81C	1/3	−45	82C	2/3
+42	81D	2/3	−55	80D	1/3
+53	81EF	1/3	−81	80C	1
+81	85C	1/3	−112	80B	1 2/3
+112	85	2/3			

CC COLOR COMPENSATING INDEX

CC+	MAGENTA	+EV	CC−	GREEN	+EV
+2	5M	1/3	−2	5G	1/3
+4	10M	1/3	−4	10G	1/3
+8	20M	1/3	−7	20G	1/3
+13	30M	2/3	−10	30G	2/3
+18	40M	2/3	−13	40G	2/3

A Light Balancing filtration system brings light back to the vicinity of 5500 degrees Kelvin through a series of amber filters for cool lighting situations, or blue filters for warm situations.

A Color Compensation filtration system, by comparison, will suggest magenta to compensate for cool lighting, or green to compensate for warm. A good color meter allows the user to select the system of filtration and then automatically computes the necessary index value. Since a higher density filter will decrease the amount of light reaching the film, each index notes the additional aperture opening required.

Supplemental Light

Supplemental lighting should be considered as any source of illumination that can be brought to a scene or subject and manipulated to achieve a desired effect. Supplemental light includes flood lamps and electronic flash, together with all the reflectors, shapers, diffusers, and intensifiers required to give the photographer complete control over a visual composition.

Photoflood lighting

Photoflood lamps—tungsten bulbs ranging in size from 250 to 1,000 watts—have been a mainstay of artificial photographic lighting for decades, providing a cheap, portable, and easily replaceable source of high-output light for indoor photography. Two or three photofloods installed in aluminum reflectors provided mid-century photographers with sufficient light for shooting portraits, groups, and small products. However, over the years, electronic flash, in the form of heavy-duty studio generators and portable battery flash units, have replaced photofloods as the lighting of choice for additional light photography.

Although flash lighting does have major advantages, which we will discuss later, photofloods—or "hot lights"—are still useful as a source of photographic illumination for a number of reasons. The main attraction of hot lights is that, as you arrange your lighting, what you see with your eyes is pretty much what you will capture on film. Misplaced highlights and annoying shadows are easily spotted, and the visual effect of every small lighting adjustment can be quickly reviewed. The ability to instantly see changes in illumination makes photofloods an appealing choice when shooting still lifes.

Photofloods are compact and lightweight. Their small size makes them particularly useful for shooting interiors. Photofloods and their reflectors can be quickly set up and moved to the far corners of an interior scene, and the resulting changes in the highlights and shadows can be easily observed. And because they emit light with roughly the same color temperature as household light bulbs, photofloods in reflectors can be used in combination with table and floor lamps to raise the overall level of illumination in a room, while maintaining the color balance.

The dark side of photofloods.

Photoflood lights burn hot—dangerously hot if you stand too close. For that reason, photofloods on lightstands are not suitable for use when working with active children or pets. And the constant heat will quickly wilt fresh fruits and vegetables, making photofloods a poor choice for most food photography. In addition, the heavy draw of current from a multi-light photoflood setup may be more than the electrical circuits in many older homes and office buildings can handle, resulting in blown fuses or burned wiring.

Color temperature.

The traditional screw-in photoflood lamp is designed to emit light at a color temperature of 3,400 degrees Kelvin, not quite a perfect match for 3,200-degree tungsten-type films. However, as the burning bulb ages, the light output drops and the color balance shifts toward red. In effect, photofloods "burn in" to the 3,200-degree range of tungsten films. In practice, the 200-degree difference is visually not too important, which is one reason why Kodak, Fuji, Agfa, and Scotch Films all rate their tungsten-type films at 3,200 degrees. Kodak also continues to market a little-known tungsten "Type A" Kodachrome, rated for use at 3,400 degrees K, but for most commercial and personal applications, photofloods and tungsten film make a very good team.

The color temperature of photofloods can also be affected by the voltage available at the bulb. If multiple lamps are being powered from the same circuit or extension cord, the actual temperature may drop as the voltage drops. And a dirty or discolored reflector will also modify the color output of light.

A new generation of hot lights.

Screw-in photofloods are remnants of earlier technology, and are rapidly being replaced by more sophisticated—and expensive—quartz lighting fixtures. A spin-off from the motion picture and video industry, quartz lights offer several advantages over traditional photoflood bulbs. The life expectancy of a quartz bulb is often 10 to 20 times that of the standard photoflood's four- to six-hour life. And quartz lamps produce their light from physically smaller bulbs.

The compact size and high output of quartz lamps has led manufacturers to design a number of trim, efficient, highly controllable quartz lighting fixtures. Most have built-in movable light control flaps called "barn doors," which can be adjusted to modifying light fall-off. Many quartz fixtures also feature focusing capability, so the light can be adjusted from a broad flood pattern to a narrow spot beam. A few lights also include forced air cooling, and these can be left on for extended periods without overheating.

Accessories include mounting brackets, clamps, screws, and plates that allow the fixtures to be mounted to almost any horizontal or vertical surface, and gel and diffusion materials that can be used to soften and color the light.

The Inverse Square Law

The theory behind the *inverse square law* affects the majority of the current technology in photographic lighting. This theory states that light diminishes at the square of the distance from the light source to the subject. This means that light in its full intensity (starting from a point source and traveling out in all directions) becomes less effective (less bright) as it gets farther away from its source, because it has a greater area to cover.

If we position a light source one foot from a subject, the intensity of that light decreases as it spreads to reach the subject. If we used our flash meter to measure the intensity of that light, we might, as an example, find that the proper exposure for the subject is $f/22$.

If we move the light source to a distance of two feet from the subject, the same amount of light would not only need to travel twice the distance to reach the subject, it would also spread over an even greater area. Therefore, the proper exposure would no longer be $f/22$. Just as the distance from the light source to the subject has doubled, the proper exposure is halved. The meter would now read $f/11$.

In principle then, the inverse square law means that if you precisely double the distance between the light source and the subject, proper exposure is achieved by opening up two stops. If you move the light source in closer to the subject by half the original distance, close down two stops for proper exposure.

Options are available for photographers who like to take the law into their own hands. If you prefer the affect of the light source placed one-and-a-half feet from the subject, but need the depth of field provided by an exposure of $f/22$, simply double the intensity of the light source. In other words, if $f/16$ was achieved at 100 watt-seconds, an exposure of $f/22$ would require 200 watt-seconds of power. Correspondingly, $f/32$ would require 400 watt-seconds of power.

It is important for the photographer to remember that the inverse square law is absolutely correct only in theory. In practical application, many ambient light conditions exist as exceptions to the rule. However, the theory provides a good starting point in determining the relationships between the distance of the light source from the subject and obtaining the proper exposure.

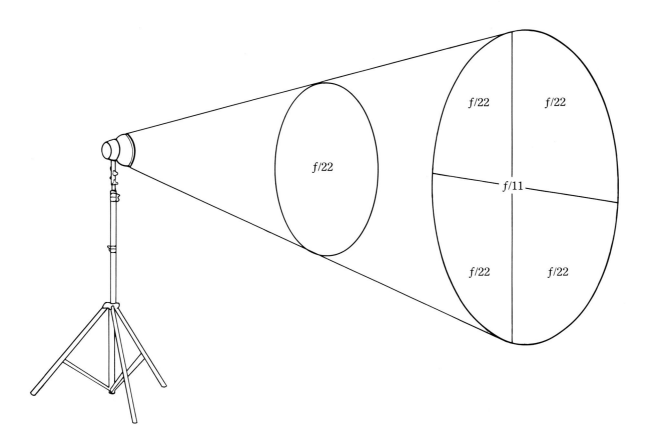

This illustration shows the affect of the *Inverse Square Law* on exposure readings. Light will become less bright as it gets farther away from its source, because it has a greater area to cover.

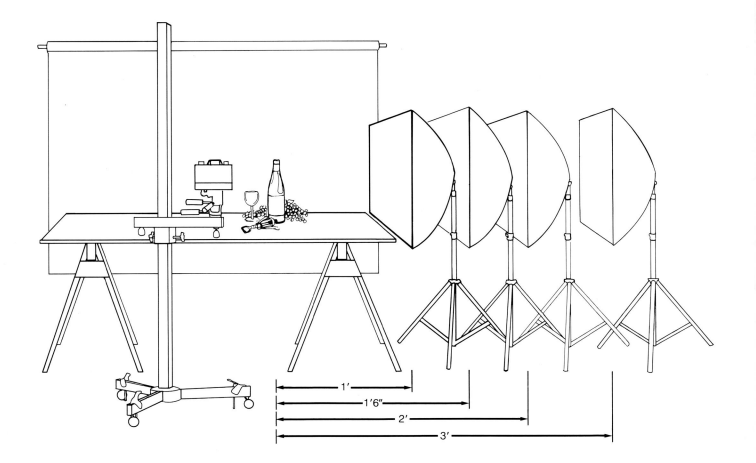

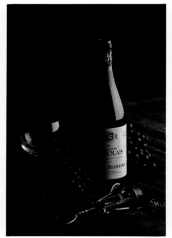
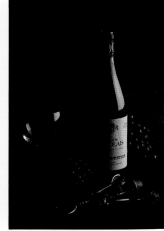

| 1 foot at *f*/16 | 1.5 feet at *f*/16 | 2 feet at *f*/16 | 3 feet at *f*/16 |

This series of photographs illustrates the theory of the Inverse Square Law as it is put into practice. In the first photograph, the light source (a Chimera Soft Box with one Novatron bare-tube head) is only one foot from the still-life set. The wine bottle reflects the front diffusion panel of the soft box with a highlight that wraps around the bottle's surface. At the same time, the corkscrew and the grapes have a rather broad highlight, while the shadow edges are soft.

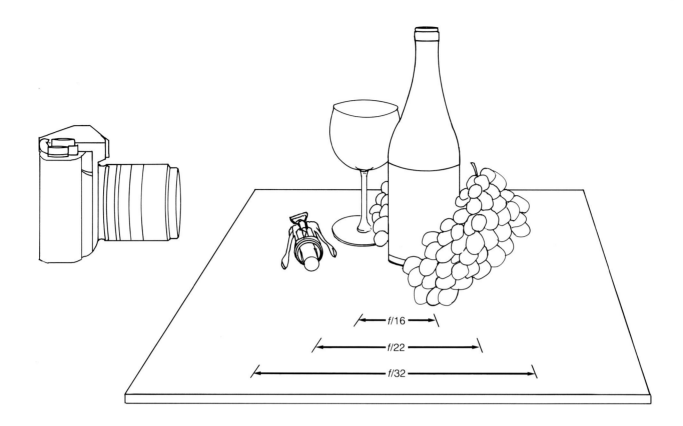

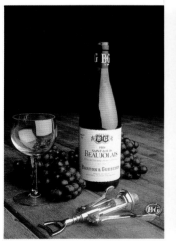

1 foot at f/22

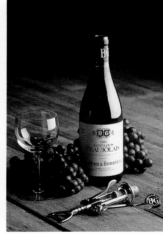

1.5 feet at f/16

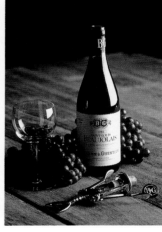

2 feet at f/11

3 feet at f/8

As the light is backed away from the set, less of its energy is striking the various surfaces. To retain a similar lighting effect, the camera's aperture must be opened further, which diminishes the depth of field, or the output of the light source must be increased. In either case, the quality of the light will be altered. Here the image has developed more contrast, and the highlight on each grape is more specular. The transfer space between the normal exposure (on the surface of the table) and the shadow (the area behind the grape) is more compressed and the shadow edge has become more pronounced. As the light source is moved farther away, many of the once-soft white reflections of the light source in the corkscrew have been traded for cold, black ones. All specular highlights now burn through the objects.

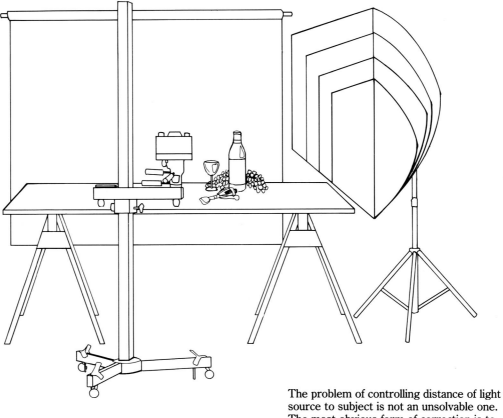

The problem of controlling distance of light source to subject is not an unsolvable one. The most obvious form of correction is to increase the size of the light source as its distance from the subject increases.

CAUTIONS WHEN USING HOT LIGHTS

Because of the great heat generated by photoflood bulbs and quartz lights, you must always pay special attention to their use:

• Don't use hot lights in shooting situations where children or pets could be burned.

• Never look directly at a burning hot light. The intense light output could damage your eyes, and hot lights can explode.

• Make sure the total electrical load for all the hot lights in use doesn't exceed the current-carrying capacity of your electric circuit.

• Use only heavy-duty, three-pronged grounded extension cords.

• Diffusion materials and colored gels should be of a type recommended for use with hot lights. Observe the requirement for minimum mounting distance between quartz fixture and diffusion or gel material. Most manufacturers include this information with the lighting fixture.

• Always turn off lights before moving them to a new location, or adding or removing diffusion materials.

Electronic Flash

By far, the most-used source of artificial illumination in photography is the electronic flash tube. Flash light—the modern cousin of flash powder and the flash bulb—offers a number of advantages and few shortcomings. It has become the illumination of choice for many photographers.

Sorting Out The Terms

The terms "strobe," "flash," and "electronic flash" are often used interchangeably, although there is a difference. A "strobe" light is usually considered to be any form of flash illumination that can be fired at a rapid rate, anywhere from a few flashes to a few *thousand* flashes per second. This type of sophisticated electronic light is most often combined with special cameras to produce high speed motion studies of phenomena that cannot normally be detected by the naked eye, although a few portable flash units and studio flash generators are capable of stroboscopic flashing.

"Electronic flash" illumination can be considered any burst of light which does not repeat at a rate faster than about one burst per second. This includes most portable flash units and studio flash generators available today.

The term "flash" can refer to any burst of light—be it strobe, electronic flash, or flash bulb—that illuminates a scene for photography. Of the many types of artificial lighting, photographers most often deal with electronic flash.

The Basics of Flash Technology

The average on-camera flash unit connecting to the camera's hot shoe consists of a small flash tube with a shiny plastic reflector behind it, a penlight battery or two, a little capacitor that develops and holds an electrical charge, and the necessary micro-circuits enabling the flash to go off on command.

When you depress the camera's shutter button, a switch inside the camera body is closed. This completes an electrical circuit with the camera body's hot shoe. The hot shoe's electrical connections make contact with those of the flash's hot foot and the flash is simultaneously fired. When the flash goes off, the energy that has been stored in the flash unit's capacitor releases a burst of power to the flash tube. The tube, which is filled with a mixture of Xenon gas and sealed in a partial vacuum, begins to ionize. The high voltage charge causes the inert, momentarily conductive gas to respond with a flash of light that lasts for only 1/1000th to 1/100,000th of a second.

Similar technology is used with a good, compact, studio flash system. However, as these systems are designed for immense versatility, they are broken down into individual components so that the photographer gains the most creative control.

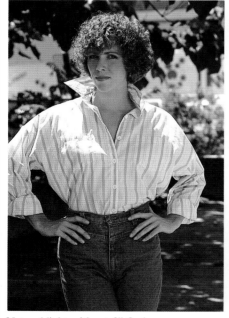
Natural light without fill flash.

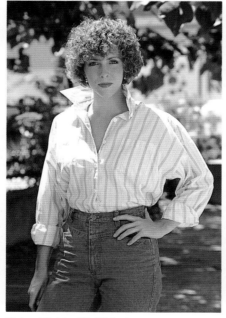
Natural light with fill flash.

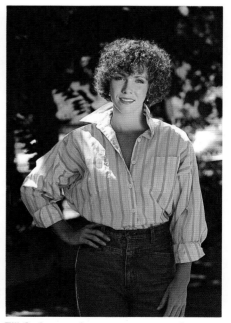
Fill flash set at incorrect sync speed.

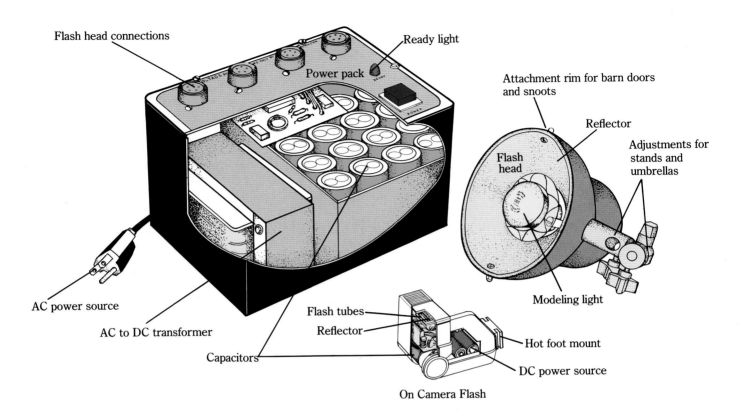

Flash head connections

Ready light

Power pack

AC power source

AC to DC transformer

Capacitors

Attachment rim for barn doors and snoots

Reflector

Flash head

Adjustments for stands and umbrellas

Modeling light

Flash tubes

Reflector

Hot foot mount

DC power source

On Camera Flash

The camera body is in electrical contact with the system through a very low amperage PC cord. The cord runs from the camera to the power pack and signals the synchronization of the opening of the camera's shutter with the firing of the flash.

The power pack's energy source is standard household AC current. Like the on-camera flash, the system operates on DC current. Therefore, a large transformer is used to convert the AC voltage to between 300 and 900 volts of DC power. (The intensity of this charge is an excellent reason for preventing the photographer from ever attempting any self-service on a power pack.) Energy is stored in a series of massive capacitor banks, portions of that energy are economically released to the flash heads on demand.

The system's flash heads are connected to the power pack through specially configured multiple-pin plugs with cables of 15 feet or more. A head consists of a large Pyrex or Quartz flash tube (preferably, although not always, color-corrected to 5500 degrees

Kelvin), a tungsten or quartz modeling lamp (to assist with viewing the subject), and connections for a series of accessories that can include highly polished or diffused metallic reflectors, umbrellas, soft boxes, and other accessories to assist in manipulating light.

The bright, action-stopping burst of light is accomplished through basically the same means as the small "pop" produced by the on-camera flash. However, the flash duration is more suited to taking optimum advantage of the time latitudes of modern color films. This duration will vary between 1/250th and 1/4000th of a second, depending on the power setting and the number of heads in use. The entire process can be repeated thousands and thousands of times with consistent results before a properly cared for flash tube will need replacement.

Recycling time Versus Power Output. An electronic flash is completely recycled when its capacitors are fully recharged. The time it takes for this to happen is known as the *recycle time.*

Every burst of light a flash unit produces drains all or part of its capacitor's stored energy. When the unit's power selector is set for its lowest output, a minimal amount of energy is drained off during the production of light. Therefore the recycle time is shorter than if the unit is set for maximum power output.

A flashing ready light and/or an audible tone is provided to indicate that a unit has completely recycled. Most ready lights flash during the recycling period and remain constantly lit when the capacitors are fully energized. Some ready lights are more enthusiastic than they should be, signaling that the capacitors are fully charged when, in reality, the charge is not up to its full potential. In such cases, the photographic results will be a bit more underexposed than anticipated.

Advantages and Shortcomings. Electronic flash is, in many ways, an ideal form of photographic illumination. Unlike the sun, the quantity, consistency, direction, and quality of flash can be precisely controlled. And, unlike photoflood lamps, flash does not produce waves of intense heat—which can wilt delicate subjects—even when a large quantity of light is generated. In addition, electronic flash is highly portable, and battery-powered flash units can be used in locations and situations where the sun doesn't shine or electrical power lines are not available. Flash also can be used to freeze very high-speed motion, a quality that neither sunlight nor photofloods offer.

On the minus side, electronic flash equipment is heavier, bulkier, and more expensive than photofloods. And, unlike the free-flowing nature of shooting in sunlight or with available light, the use of electronic flash often eliminates the spontaneity between photographer and subject. In addition, the effect of a short burst of flash lighting on a subject is difficult to determine, so visualizing the finished image is harder than it would be when shooting with the continuous illumination of the sun or other available lighting. (In sophisticated flash systems, quartz modeling lamps are usually installed as integral parts of the flash heads, allowing the photographer to see an approximate rendering of the play of light falling on the subject.)

But even with these disadvantages, electronic flash illumination still provides the unparalleled control and consistency needed for the highest quality results in fashion, portraiture, food, sports, news, and still-life photography.

Measuring Flash Output

A number of different methods are used to describe the light output of an electronic flash unit. Manufacturers of portable, camera-mounted, battery-powered flash units usually refer to the *guide numbers* of their products. A flash guide number (GN) gives an

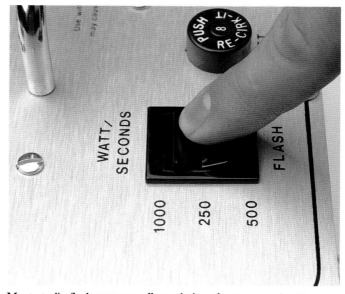

Most studio flash systems offer a choice of watt-second settings.

And some allow you to control the level of light ratio.

indication of how much light the unit throws out, in relation to a standard film emulsion speed. You therefore see guide numbers listed in conjunction with ISO film speed numbers, such as "GN of 100 when used with ISO 100 film." The higher the guide number, the more powerful the flash. Just remember, when comparing output levels of portable flash units from different manufacturers, make sure both guide number ratings are for identical film speeds.

In addition to indicating relative light output, guide numbers can also be used to set *f*-stops on non-automatic-exposure flash units. Simply divide the guide number by the flash-to-subject distance. The result will be the correct *f*-stop. (For example: using a flash with a GN of 160 for ISO 100-speed film, and a flash-to-subject distance of 10 feet, the lens aperture ring should be set for *f*/16.) Fortunately, the light-sensing cells and microchip circuitry found in most modern portable flash units has made guide

number calculation unnecessary. You need only dial in the speed of the film you are using, then either choose an *f*-stop, or let the camera and flash work together to meter and control the exposure automatically.

When discussing the light output of larger, AC-powered studio flash systems, the term "guide number" is generally replaced—at least in the United States—by "watt-seconds." Unlike guide numbers, watt/second (w/s) ratings do not depend on ISO film speeds. However, there is a simple one-to-one relationship between watt/seconds and *f*-stops: double the w/s output, and the camera aperture can be set one *f*-stop smaller; divide the watt-second rating in half, and the aperture should be set one *f*-stop larger. This is a particularly useful way for photographers working with large, adjustable flash power packs because it permits quick changes of light levels without complicated calculation. Watt-second ratings are also a good way to compare two flash systems, as the w/s light output is measured at the same distance from the flash tube, using similar reflectors.

Not all flash systems are created equal. One system rated at 1000 watt-seconds may provide a reading of *f*/32, while another similarly rated system will provide a reading of one stop less under the same conditions.

It is important to remember that watt-seconds is a term representing the measurement of the consumption of electrical power, much in the same way that kilowatt-hours represent your electric company's method of measuring the amount of electricity you use. Though the power pack's electrical consumption is somewhat relative to its light output, there are many factors that prevent the use of the watt-second rating as an honest comparison of any two units. A more accurate comparison would be based on: the efficiency of each unit's internal components, the design of the flash head as well as its reflector, the size, shape, color, and texture of the space in which the unit is being used, the light measuring device of the unit, and even the length of its cord.

The best method of evaluating flash systems is with a high-quality flash meter in a side-by-side comparison using flash heads and reflectors designed for a similar function. Additional considerations in choosing a flash system include: color temperature, portability, recycling time, system features, availability, and, of course, light output to dollar value.

While guide numbers usually range from about 50 to 250 for portable flash units, watt-second ratings often run from 50 to 10,000, indicating the much broader, more powerful range of light available from studio flash units, although the majority of generators sold are in the 400 to 5,000 w/s range.

There are other, less popular ways of rating flash light, including the Beam-Candlepower-Second Output (BCPS) system, and the Joule (J) system of indicating electrical energy expended, which is used in some European countries. But for the majority of American photographers, guide numbers and watt-seconds are the two standard tools used to evaluate the relative output of flash units.

Controlling Flash Duration

Recycle time is of minor importance to the still life photographer using an 8×10 view camera. But the fashion photographer intent on capturing the model's best moments in a flash will have an opposite point of view. In the latter's case, a decision must be made in favor of either 1600 watt-seconds and *f*/32 with a two-second wait between exposures, or 400 watt-seconds and *f*/16 with a rapid recycle of two shots per second.

Special photographic situations call for the capturing of an event which lasts but a very brief fraction of a second. To stop such action requires a burst of illumination that begins and ends in a shorter time span than that necessary for portraiture or still life.

The use of a flash system at the unit's full power output provides the longest flash duration. For example, if a 100 watt-second power pack is determined to have a 1/750th sec. flash duration at its full, 1000 watt-seconds, reducing the power setting of the unit to one half the output, 500 watt-seconds, would have the duration to 1/1500th sec. Correspondingly, 250 watt-seconds would provide a flash duration of 1/3000th sec.

Flash duration is reduced further as more flash heads are added to the power pack. Therefore, the shortest possible duration is achieved when the power pack is on its lowest setting and the maximum number of heads are in operation.

Exposure Variables. Electronic flash provides a number of creative exposure options that are unavailable with ambient-light or hot-light photography.

One exposure factor is the duration of the flash. In most cases, this is determined by the speed with which the action is captured and the setting to which the aperture is opened.

A second variable can be the shutter speed. How a shutter speed is set for flash synchronization varies from camera to camera, as does the workings of the shutter. Focal plane shutters, like those found in most 35mm SLRs, have a maximum speed at which the movement of the shutter can be fully synchronized with the flash. This is often marked on the camera body with a colored "X," or on the speed selection dial with a number of a different color than that of the rest. Maximum sync speeds usually range from 1/30th sec. to 1/250th sec., but a slower speed may normally be selected without a problem.

Many creative photographers use slower sync speeds to their advantage. In a controlled environ-

ment, the flash can properly expose the subject while a slower shutter speed can burn-in the ambient background, produce a beautiful blur, or allow the photographer to paint with light.

Higher-than-maximum shutter sync speeds produce another unique, but often undesirable, result. As the opening in the shutter curtain rapidly travels across the focal plane, it fails to place all of the image onto the film as exposed by the flash, leaving a portion of the frame properly rendered and the rest darker than anticipated.

Cameras without focal plane shutters—view cameras, some medium-format cameras, and some small 35mm fixed-lens cameras—can synchronize at any shutter speed.

Electronic Flash Systems and Contrast Ratios.
Flash systems provide a wide variety of methods that allow the photographer to manipulate light. These are limited only by the imaginations of the photographers and system designers.

A power pack that has been adjusted to produce 100 watt-seconds of power can send all of that power into one flash head. When a second flash head is introduced, the power is evenly divided between both heads at 500 watt-seconds each. This is known as *symmetrical power distribution.*

Asymmetrical power distribution divides the intensity of light unequally between flash heads. This provides for a multitude of contrast ratio combinations, compensations for various problems, and unique special effects. Just as the flash output is altered, the intensity of the modeling lights are often adjustable as well.

Not every system offers the photographer a choice between symmetrical and asymmetrical power distribution. Depending on your photographic needs, this may become an important consideration in choosing one system over another.

Controlling the Quality and Quantity of Flash
In terms of color quality, electronic flash is very similar to that of sunlight, with most units producing light of about 5,500 degrees Kelvin, although flash color temperature can easily be altered to create a warm or cool mood. Because flash tubes don't give off a great amount of heat (except when used in conjunction with high-wattage modeling lights) colored gels are used over the flash, rather than over the camera's lens, to change the color of the light output. A few manufacturers also offer specially-coated flash tubes that produce a higher or lower Kelvin temperature for photographers who want warmer or cooler results.

The "character" of electronic flash, the intensity, direction, and softness or harshness, are controllable with a variety of lighting accessories.

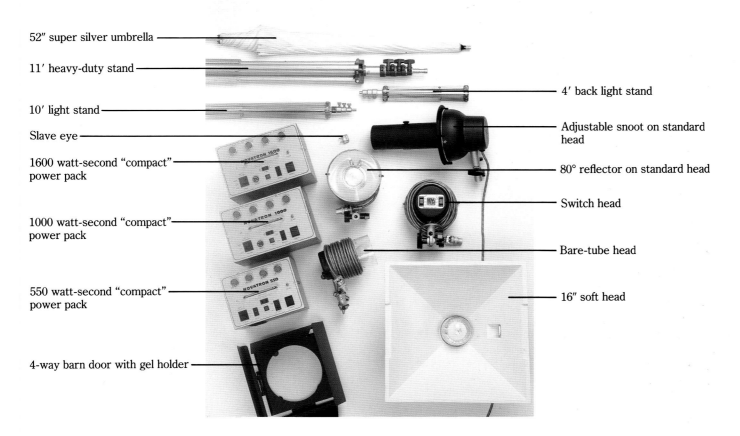

52″ super silver umbrella

11′ heavy-duty stand

10′ light stand

Slave eye

1600 watt-second "compact" power pack

1000 watt-second "compact" power pack

550 watt-second "compact" power pack

4-way barn door with gel holder

4′ back light stand

Adjustable snoot on standard head

80° reflector on standard head

Switch head

Bare-tube head

16″ soft head

Reflectors. The basic *reflector,* which fits around the flash tube head, can be used to concentrate or spread a beam of flash light. Reflectors are available in a variety of matte and high-gloss surface finishes, in a number of diameters, and with many side-wall angles, all of which allow the photographer to custom-tune the spread, throw, and harshness of flash.

The photographic umbrella. Another way to control flash light is by using umbrellas, which are available in an extensive range of shapes, sizes, and surface finishes and colors. With most umbrella systems, the flash head, housed in a small reflector, is mounted on the umbrella stem, and aimed toward the fabric. Flash light is then thrown into the material and bounced out toward the subject. Depending upon the diameter and shape of the umbrella, the resulting throw of light could be fairly wide or concentrated. The choice of a metallic umbrella fabric will increase the amount of light bounced toward the subject, while also increasing the contrast between highlights and shadows. A matte-white surface, on the other hand, will decrease the amount of light and also decrease the contrast range of the subject.

Umbrellas are available in rectangular, square, and round shapes, in diameters from one to six feet, and in matte or metallic shades of white, gold, and silver. As umbrellas are one of the most-used tools of lighting, photographers go to great lengths to refine and tailor umbrella systems to their personal tastes.

Diffusion boxes. A step up from umbrellas are *diffusion boxes, soft boxes,* or *light banks,* carefully designed enclosures which contain one or more flash heads. The flash light output is aimed at the open front face of the box, which can be covered with a variety of translucent materials such as Plexiglas, white nylon "parachute cloth," muslin, or silk. The interior of the box can be lined with a matte-white surface to increase light diffusion, or a silverized material to increase light transmission. The light from a properly designed diffusion box is very soft and even from corner to corner, and will illuminate subjects with a beautiful, diffused light that resembles the north skylight so admired by artists.

An entire sub-industry has evolved to supply photographers with diffusion boxes of every type, from small, collapsible, nylon models used for location shooting, to large, fiberlgass and steel boxes mounted on movable stands and used to light everything from tortillas to trucks.

Other flash lighting control equipment includes "honeycomb grids," which add direction and precise fall-off to light from a diffusion box or flash with reflector, and focusing flash spots, which use Fresnel lenses to concentrate light in narrow beams.

Photographic umbrellas come in a variety of shapes, sizes, colors, and surface finishes. Shown here are silver lamé, white, and silver.

Summary

No single volume could possibly cover all the technical aspects of photographic lighting. In Part 1 we have presented an overview, which should enable you to understand the basic elements of lighting and help carry you through the detailed lighting discussions presented in Part 2. The most productive learning will come when you take camera in hand and begin to experiment with the lighting setups we describe, then move on to create your own unique images with light.

Many of the photographs that follow in this book were created with view cameras rather than 35mm SLRs. Many photographers feel uncomfortable using a sheet-film camera, as its operation is considerably less instantaneous than those of the current automated SLRs.

The advantages of the view camera extend beyond its film size of 4×5, 8×10, and larger. A view camera becomes a must to many still life and architectural photographers because the camera's front lens plane and rear film plane move horizontally, vertically and tilt and swing. This allows for the manipulation of light from the time it enters the front element of the lens until it comes in contact with the film itself. Subjects with an unattractive perspective can be controlled and manipulated until lines become beautifully parallel. An object that appears to be obscured by another can be made visible. That which was out of focus can be coaxed into clarity.

All of the principles of lighting in relation to view camera operation are exactly the same as those of a 35mm. There is no good reason to shoot 4×5 images when 35mm will do, but there are many times when a sheet film camera will dramatically enhance the photographer's image making.

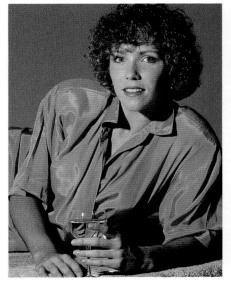

Bare-tube head

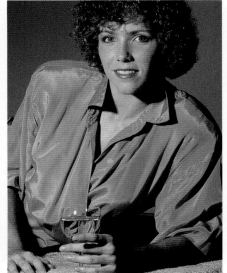

Standard head

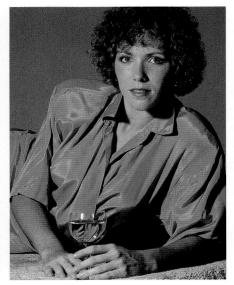

16″ soft head

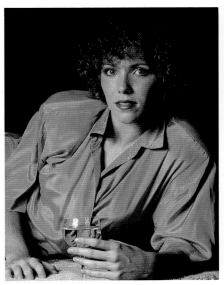

54″ silver umbrella

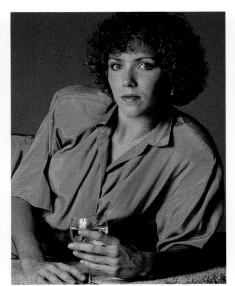

54″ white umbrella

Silver lamé umbrella

Medium Chimera head

The character of electronic flash can be controlled with a variety of lighting accessories. These photographs show the effect produced by some of the most popular types of equipment.

PART TWO

USING LIGHT

A solid understanding of the theory of light in photography goes hand-in-hand with the personal ingenuity to adapt basic principles to real-life situations. Mastering one and not the other makes for a limited repertoire of photographic skills.

Light is one of the photographer's most essential pieces of equipment, but it is merely equipment and must be used in concert with creative vision. Ultimately, using light well will help you make your point photographically, whether the pictures are taken for your own artistic expression or to suit a client's needs.

The principles of good lighting should become second nature in photography. Only then will they become the foundation upon which you can expand your abilities. How you use light becomes a matter of personal expression; part of the signature that determines your photographic style.

No amount of theoretical knowledge can substitute for simply looking through the camera and *seeing* the affect that light has on a subject. It is well worth the effort to take the time to experiment, for it is through this experimentation that new avenues of expression are found.

The photographs that follow show how different photographers have responded to the existing light in a variety of situations, or how they have created lighting effects in the studio. Some of these effects were created quite simply, others are more complicated. But in all cases, the photographers have used light to benefit the subject or create a specific atmosphere.

As with photographic theories, these examples should be seen only as that—examples of how other photographers have made effective use of light. You, in turn, should use them only as guidelines, not as strict recipes to be followed for your own work. Imitation leads only to repetitive imagery, not exciting photography.

Natural and existing light are often not matters of choice. However, as you will see, any form of light can be controlled, modified, and even exploited to bring out the best in your work. In the studio, you can choose your lighting setup in much the same manner that you choose your camera, lens, and film. The extent to which you decide to manipulate light is limited only by the exposure latitude of your choice of film and the range of your imagination.

Early Morning Sun

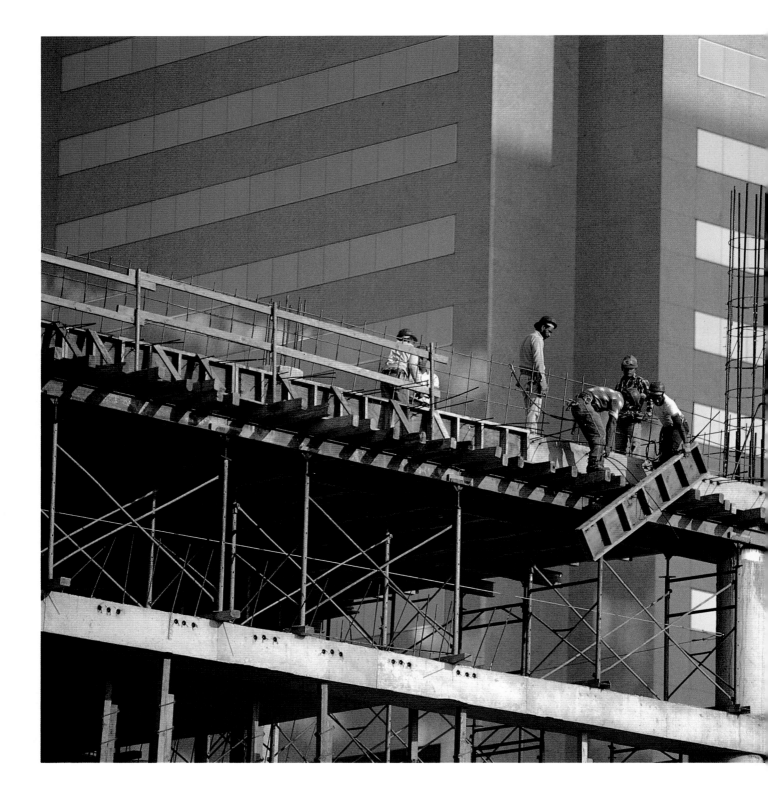

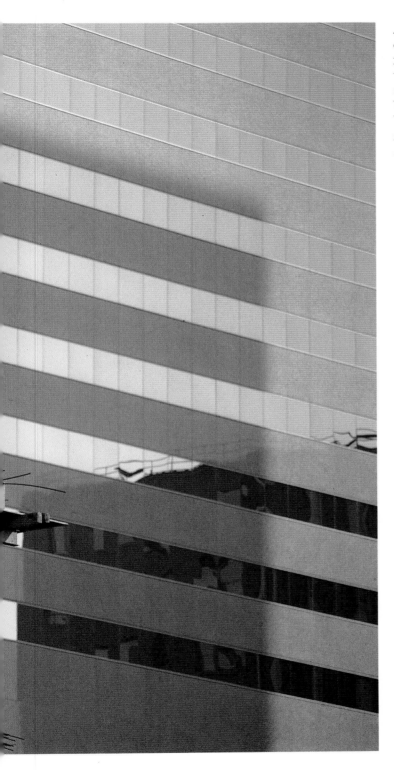

A visually appealing combination of cool, diffused, early morning light and warm, direct rays from the rising sun. The glass and steel walls of the building in the background are illuminated mainly by bluish skylight, while the workmen in the foreground are bathed in direct, yellow-orange light from the sun. When possible, experienced photographers will take advantage of this type of light to isolate a foreground subject from the background.

Photographer
Mike Pocklington

Equipment
Nikon FA camera, Nikkor
75–150mm *f*/3.5 zoom lens

Film
Kodachrome 64 Professional

Light
Early morning sun, clear sky

Early Morning Sun

An elegant combination of cool, blue shadows and warm, red rays of the morning sun. Determining the correct exposure for this type of scene is difficult because of the great difference between the highlights in the sky and the shadows of the mountains. Using your in-camera exposure meter, take an average reading that includes a portion of the sky and a portion of the dark mountains. If possible, bracket your shot as much as one stop above and below the metered exposure.

Photographer
Mike Pocklington

Equipment
Nikon FA camera, Nikkor 55mm
f/2.8 Micro lens

Film
Kodachrome 64 Professional

Light
Early morning sun

Early Morning Sun

An early morning scene, and the sun adds special color and dramatic interest to the photograph. The sun's warm glow mixes with the colors of sand and grass to produce golden-toned hues, while the low angle of the sun on the horizon creates long shadows in the foreground, which photographer Mike Pocklington has used to strengthen the visual composition of his image. Had this shot been made at noon, the overhead position of the sun would have resulted in a much flatter, less dramatic image.

When shooting into the sun for a silhouette effect, there is really no "correct" exposure. If you use the camera's built-in meter, avoid reading the direct light from the sun. This will throw your exposure calculations completely off and may even damage your meter or camera. Instead, move in close and take a tight reading of the pale sunlight falling on the subject's face. Or, using an auxiliary meter, position yourself near the subject with the meter's diffusion dome facing away from the sun, then make an incident reading of the skylight. With either method, use the reading only as a starting point, then—if time and your subject permit—shoot half- and full-stop brackets around your indicated exposure.

In this beach scene, less exposure would have created a deeper and more saturated blue sky, but would also have put the couple's faces into darker shadows, making their pleasant expressions unreadable.

Remember that as you aim a lens more directly toward the sun, spurious reflection of light within the lens barrel—"lens flare"—increases, and contrast and sharpness of the image decrease. Used in moderation, lens flare can add a diffused, dreamy, romantic look to a photograph.

Photographer
Mike Pocklington

Equipment
Nikon F-3 camera, Nikkor 85mm
f/1.4 lens

Film
Kodachrome 64 Professional

Light
Early morning sun, backlighting

Mike Pocklington captured this early morning runner in midstride with a 180mm telephoto lens and slow-speed color film. The warm tones of the rising sun complement the flesh tones of the runner, and because the sun was still low on the horizon and undiffused by sky and clouds, the light is more directionally intense. The result is deeper shadows that help "sculpt" the runner's muscular build and also black out the background colors.

Because of the slow speed of the color film (ISO 64) Pocklington used a faster-than-normal f/2.8 telephoto lens to make possible a combination of reasonable depth-of-field and an action-stopping shutter speed.

Photographer
Mike Pocklington

Equipment
Nikon F-3 camera, Nikkor 180mm f/2.8 ED lens

Film
Kodachome 64 Professional

Light
Early morning sun, sidelighting

Early Morning Sun

Early morning light on an overcast day, while pleasantly diffused, can be decidedly cool blue and gray in color. In this photograph, the diffused light moderated the intensity of shadows on the face, while still maintaining the strong highlights on the runner's hair. To warm the flesh tones, the photographer used salmon-colored 81A filter over the lens. As an alternative, a color slide film with a warmer "personality" could also have been used.

The out-of-focus trees provide a pleasantly soft, green background to the main subject. This effect was achieved by using a long telephoto lens with a very fast *f*/2 maximum aperture. When used at a wide aperture, the lens creates a shallow band of sharp focus, with both foreground and background softly blurred.

Photographer
Mike Pocklington

Equipment
Nikon F-3 camera, Nikkor 200mm *f*/2 IF-ED lens

Film
Kodachrome 64 Professional

Light
Early morning sun, diffused through cloud cover

Additional equipment
81A filter

Another example of cool, blue, morning light from an overcast sky. The grays and whites of the cement wall and the stacked hurdles remain cool, while the runner's fleshtones are warmed by the addition of an 81A filter over the lens. An overcast sky has diffused the sunlight, moderating the intensity of the shadows.

Photographer
Mike Pocklington

Equipment
Nikon F-3 camera, Nikkor 200mm
f/2 IF-ED lens

Film
Kodachrome 64 Professional

Light
Early morning, overcast sky

Additional equipment
81A filter

Diffused Sun

Shooting this portrait outdoors under shade trees had both advantages and disadvantages. While the overhanging branches diffused the strong sunlight as it fell on the subject, the light also picked up a green cast as it filtered through the leaves, adding green to the subject's skin tones and white shirt. Using an 81A filter would have warmed the rendering slightly.

Notice also the pleasant out-of-focus background colors and highlights, which work to visually emphasize the sharply focused subject. This effect was achieved by employing a fast f/2.8 telephoto lens set at a wide aperture, thereby creating a shallow band of focus—"depth of field"—while blurring the background and foreground.

Photographer
Mike Pocklington

Equipment
Nikon F-3, Nikkor 180mm f/2.8 ED lens

Film
Kodachrome 64 Professional

Light
Midday sunlight, filtered through trees

Some subjects benefit from the cool, diffused light of a cloudless sky, as is the case with this image of drying red chili peppers hung against a background of blue canvas. Because the scene does not include people, a viewer has no skin tones to use as reference points in determining the "correctness" of the color. The brilliant red and blue rendering is accepted as an accurate photograph of the scene.

The diffused light from an overcast sky moderated the contrast range of this image, producing open shadows, saturated red and blue middle tones, and clean but moderate highlights.

Photographer
Mike Pocklington

Equipment
Nikon F-3, Nikkor 75–150mm *f*/3.5 zoom lens

Film
Kodachrome 64 Professional

Light
Diffused skylight from an overcast sky

Diffused Sun

An extreme example of how sunlight, heavily diffused by an overcast sky, mutes colors, lowers contrast, and opens up dark shadows. In this photograph, the only outstanding colors are found in the model's blonde hair and the orange and green of the flowers. Because of the low intensity and diffused nature of the light, these colors are further subdued. And although the diffused light lowers the contrast range between the brightest and darkest areas of the picture, there is still sufficient shadow detail to separate the model's white dress and coat from the white background.

Photographer
Mike Pocklington

Equipment
Nikon F-3, Nikkor 200mm *f*/2 IF-ED lens

Film
Kodachrome 64 Professional

Additional equipment
81A filter

Photographer
Mike Pocklington

Equipment
Nikon F-3, Nikkor 200mm *f*/2 IF-ED lens

Film
Kodachrome 64 Professional

Light
Sunlight diffused by overcast sky

Diffused sunlight from an overcast sky renders soft, subtle colors and shadows, while maintaining the clean, white tones in the model's skirt. To slightly soften and separate the foreground from the background, a long telephoto lens was used at a wide aperture.

Midday Sun

An example of an unappealing photograph made with uninspiring midafternoon light. The shadows are deep, but not deep enough to mask an uninteresting background. The head-on, overhead angle of the sun does little to enhance the weathered surfaces of the boat and the dock. And the middle-of-the-road exposure of this high-contrast scene results in weak, washed-out colors. Faced with this type of lighting, try walking around the subject, looking for a more dramatic play of light and shadow, or tighten the composition, either by moving in closer to the subject or by using a telephoto lens.

Photographer
Mike Pocklington

Equipment
Nikon F-3, Nikkor 75–150mm *f*/3.5 zoom lens

Film
Kodachrome 64 Professional

Light
Strong midday sun

Photographer
Mike Pocklington

Equipment
Nikon F-3 camera, Nikkor
75–150mm f/3.5 zoom lens

Film
Kodachrome 64 Professional

Light
Strong midday sun

The lighting conditions for this photograph were
similar to those of the previous example, but this
image is visually appealing because the photographer
has zeroed in on an exciting combination of strong
graphic design, texture, color, and lighting.

Midday Sun

In this example of portraiture using strong sunlight, the model was posed facing away from the sun in order to create a lively halo of highlight around her hair. A white reflector was then positioned below and to the right of the camera to add light and fill in the shadows on the model's face. Exposure was determined by ignoring the strong backlight and metering only the light falling on the face.

Facing the model away from the sun and using a moderate level of fill lighting made for more comfortable posing, with a minimum of squinting by the subject.

The Flexfill reflector used to create this photograph is just one of a variety of devices available for bouncing light. However, the Flexfill is the most portable. Folding white umbrellas, in square and rectangular shapes, are also widely used, as is white posterboard or "Fomecore" board, a lightweight, 1/4"- to 5/8"-thick semi-rigid foam panel available in sheet sizes up to 4' × 8'.

Photographer
Mike Pocklington

Equipment
Nikon F-3 camera, Nikkor 200mm
f/2 IF-ED lens

Film
Kodachrome 64 Professional

Light
Strong midafternoon sun

Additional equipment
White Flexfill reflector

Midday Sun

In making this picture, photographer Mike Pocklington made good use of harsh lighting. The midday sun was the source of deep shadows, but by positioning himself so the oncoming riders were slightly backlit, Pocklington used the light to separate and outline the riders. Aiding the effect was a dark, shadowed background.

Photographer
Mike Pocklington

Equipment
Nikon F-3, Nikkor 180mm *f*/2.8 ED lens

Film
Kodachrome 64 Professional

Light
Midday sun

Photographer
Mike Pocklington

Equipment
Nikon F-3, Nikkor 200mm *f*/2
IF-ED lens

Film
Kodachrome 64 Professional

Light
Midday sun

Additional equipment
Silver Flexfill reflector

When shooting outdoors, the harsh effect of direct sunlight can be softened by posing the subject in open shade. Unfortunately, shadows tend to deepen in shade, and fill-in lighting must often be added. In this photograph, the model was posed so the sunlight illuminated her from behind, while additional light diffused through surrounding trees lit the model's face. A reflective silver Flexfill panel was positioned to the right of the camera to eliminate dark shadows and bring up the total level of illumination on the face.

The background, a strong pattern of tree limbs, leaves, and sky, could have been visually overpowering. To soften the background, the photographer used a long telephoto lens set at a wide aperture, which allowed for a tight framing of the subject while keeping the leaves out of focus.

Late Afternoon Sun

Intense sidelight raking across the weathered wood and strands of rope creates strong shadows, enhancing the sense of texture. Had the sun been directly behind the photographer, the shadows—and the sense of texture—would have been eliminated.

Photographer
Mike Pocklington

Equipment
Nikon F-3, Nikkor 75–150mm *f*/3.5 zoom lens

Film
Kodachrome 64 Professional

Light
Strong midafternoon sun

In this photograph, the sun again provides strong sidelighting, but here the surface of a concrete wall is used to bounce light into the shadows on the model's face. While the strong sculpting effect of the sun seems appropriate for this "masculine" image, it would be less appealing if used to photograph a woman or child with softer features.

As this photograph demonstrates, you don't always need to pack fill umbrellas or reflectors when shooting outdoors. A white wall, a large white handkerchief, or even a sheet of newspaper can be used to bounce light into dark shadows. Just remember that if you use a reflector with a colored surface, your subject will show the color from the reflecting surface.

Photographer
Mike Pocklington

Equipment
Nikon FA camera, Nikkor 200mm f/2 IF-ED lens

Film
Kodachrome 64 Professional

Light
Late afternoon sun

Late Afternoon Sun

Strong sidelighting can add dramatic appeal to outdoor photography of people, but care must be taken to observe the effects of deep shadows on the subject's face. In this photograph, sunlight from the left of the camera emphasized the texture of the wooden fence, but put one side of the model's face and dress into deep shadow. Two white folding reflectors, both placed to the right of the camera, were used to bounce sunlight into the dark side of the scene, opening up the shadows and making the color and detail in the model's dress more readable.

Photographer
Mike Pocklington

Equipment
Nikon F-3 camera, Nikkor 200mm *f*/2 IF-ED lens

Film
Kodachrome 64 Professional

Light
Late afternoon sun

Additional equipment
Two white Flexfill reflectors

Late Afternoon Sun

Again, lighting has helped separate the subject from the surroundings in this photograph, and has also enhanced the white lines of the dingy, the red color of the float, and the blue of the water.

Contrasting colors can be further separated by making use of reflections. In this case, the dingy's clean white colors reflect the blue tones of the water. The red float remains noticeably uncontaminated because of its considerably deeper color.

Photographer
Mike Pocklington

Equipment
Nikon F-3 camera, Nikkor 75–150mm *f*/3.5 zoom lens

Film
Kodachrome 64 Professional

Light
Late afternoon sun

Just after sunrise—and just before sunset—the proximity of the sun to the horizon tends to focus and channel the light, creating an effect similar to a giant spotlight. In this photograph, the rays of the late-afternoon sun have been partially blocked by surrounding hills and trees. The result is the dramatic separation of the highlighted boat and float from the deeply shadowed background.

Photographer
Mike Pocklington

Equipment
Nikon F-3, Nikkor 200mm *f*/2 IF-ED lens

Film
Kodachrome 64 Professional

Light
Late afternoon sun

Late Afternoon Sun

As the afternoon sun dips lower in the sky, the color of the light becomes golden, and in this photograph the reds have become even redder.

Though the red "long johns" may have the same tone and hue as the garage door, the shadow area of the door becomes cooler in tone, providing a dynamic contrast between the two.

Photographer
Mike Pocklington

Equipment
Nikon F-3 camera, Nikkor 55mm
f/2.8 Micro lens

Film
Kodachrome 64 Professional

Light
Late afternoon sun, diffused through trees

Late Afternoon Sun

Late afternoon sunlight floods into this scene at a low angle, enhancing the highlights and shadows, sculpting and separating the tables, umbrellas, and chairs. The same shot made at high noon would seem flat and two-dimensional.

Photographer
Mike Pocklington

Equipment
Nikon FA camera, Nikkor 105mm *f*/2.8 Micro lens

Film
Kodachrome 64 Professional

Light
Late afternoon sun

Photographer
Mike Pocklington

Equipment
Nikon F-3 camera, Nikkor 35mm
f/1.4 lens

Film
Kodachrome 64 Professional

Light
Late afternoon sun

Strong late afternoon sidelight from the setting sun added brilliant highlights and deep shadows to this pine forest scene, enhancing the sense of texture and depth. The same scene photographed at high noon would seem flat and two dimensional.

In nature, of course, the trees in both the foreground and background are the same color.

However, the existing hazy conditions caused the more distant subjects to appear cooler in quality. This is due to the light reflecting off of the moisture particles in the air. This not only alters the perception of the Kelvin temperature of the scene, but also creates a beautiful contrast within the setting.

Sunset

Mike Pocklington has captured a sun setting over water in a less-than-traditional manner. There are many times when it is not possible to create a sunset exploding in yellows, oranges, and reds. In this case, the mood of the scene is accentuated by the rich deep blues of the water and the sky. The blues are enhanced by an underexposure of three stops from the meter reading. Greater color saturation exists throughout the image, and a buildup of contrast eliminates the shadow detail, intensifying the mood of the photograph.

Photographer
Mike Pocklington

Equipment
Nikon F–3 camera, Nikkor 85mm
f/1.4 lens

Film
Kodachrome 64 Professional

Lighting
Sunset

Photographer
Mike Pocklington

Equipment
Nikon F-3 camera, Nikkor 35mm
f/2.8 Perspective Control lens

Film
Kodachrome 64 Professional

Light
Sunset

In this photograph, the last rays of the setting sun have added a warm glow to the cold concrete and glass of the skyscraper. Reinforcing the glow is a *re-reflection* of the building on the water, as well as a palette of red, yellow, and pink tones in the sky.

Determining the correct exposure for this type of scene, with its wide range of highlights and shadows, can be difficult. An in-camera meter aimed squarely ahead will read not only the bright reflected light in the glass and the water but also the dark vertical bands of the tanks framing the main image. Such a reading should be used as a starting point, from which a series of bracketed exposures of up to one *f*/stop over and under the reading can be made.

Working With the Weather

An overcast day can provide effective natural lighting for both diffused illumination and a cool, moody quality. Mike Pocklington made effective use of both results for this advertisement for winter coats, which had to be photographed in August. The absence of a clean, crisp skylight provided for less prominent rendition of the background, which in turn focuses the viewer's main interest on the product.

Photographer
Mike Pocklington

Equipment
Nikon F–3 camera, Nikkor 220mm *f*/2 IF-ED lens

Film
Kodachrome 64 Professional

Lighting
One Fomecore panel

Even the light available on rainy, foggy, snowy, or other "bad" days can make for good photography. In this photograph, puddles of rainwater reflected the yellow wall of an industrial building, adding a colorful enhancement to what could have been a dull photograph.

Photographer
Mike Pocklington

Equipment
Nikon F-3 camera, Nikkor 200mm
f/2 IF-ED lens

Film
Kodachrome 64 Professional

Light
Early morning sun diffused by fog and rain

Working With the Weather

Sunrise, diffused through a light cover of fog, here turns a rural scene into a subtle, almost monochromatic photograph. The combination of diffused light and mist found in daytime fog will soften a scene, eliminating harsh shadows and textures, and at the same time take the edge off sharply focused lines. Despite the lack of brilliant highlights, a fog scene can be surprisingly bright. Built-in camera meters can be fooled by this horizon-to-sky covering of white. The best technique for this situation is to use the palm of your hand as a reflective surface, from which you can make an averaged reading of a portion of the light striking the scene. As an alternative, use an auxiliary meter in the incident light mode, and make a series of bracketed exposures.

Photographer
Mike Pocklington

Equipment
Nikon F-3 camera, Nikkor 55mm
f/2.8 Micro lens

Film
Kodachrome 64 Professional

Light
Early morning sun, diffused by
thick fog

The fields of snow and partially overcast sky in this scene combined in a cold, blue rendering, which is difficult to read correctly with a built-in camera meter. Snow is an extremely good reflector of light, and, with a few exceptions, most camera meters aimed directly at such a vast expanse of white will indicate an exposure that will render surrounding trees, people, or buildings darkly underexposed. A few of the latest generation cameras, including the Nikon FA used to make this photograph, utilize advanced systems of light metering, comparing the current results against a microchip memory "history" of hundreds of thousands of other similar light readings. The camera then electronically decides which form of exposure compensation will produce the best exposure.

If you are not yet the proud owner of one of these "thinking" cameras, you can still make excellent exposures with the fog metering technique: Use the palm of your hand as a reference for making a close-in average reading of the light falling on the scene. Or use an auxiliary meter in its incident-reading mode, remembering to position the dome light receptor to minimize the effect of intense reflections from the snow.

Photographer
Mike Pocklington

Equipment
Nikon FA camera, Nikkor
75–150mm f/3.5 zoom lens

Film
Kodachrome 64 Professional

Light
Midafternoon sun

Bringing the Outdoors In

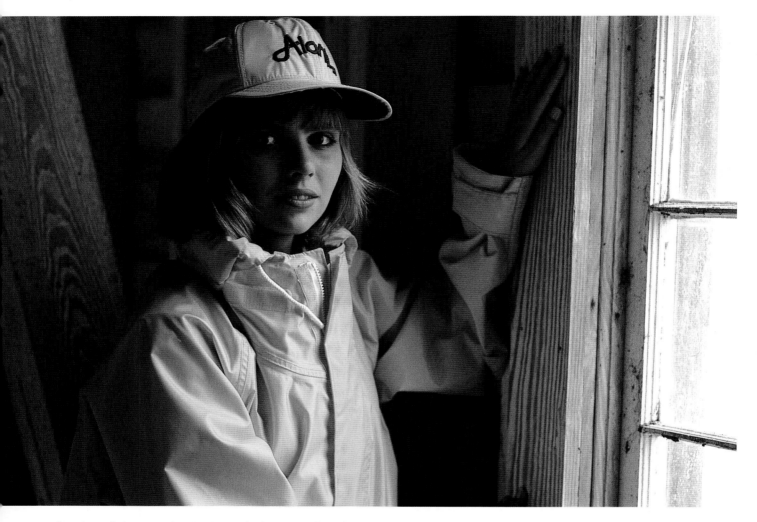

Outdoor light can also be brought indoors. In this photograph, the skylight coming through the window is used as a flattering form of diffused sidelighting. In addition, the window frame shapes the light and makes it more directional, so a confusing background can be hidden in dark shadows. An 81A filter was used to slightly warm the cool skylight. If you were concerned about minimizing the subject's facial lines and wrinkles, a white reflecting surface placed to the left of the camera could be used to fill in shadows and hide wrinkles.

Photographer
Mike Pocklington

Equipment
Nikon F-3, Nikkor 85mm *f*/1.4 lens

Film
Kodachrome 64 Professional

Light
Sunlight diffused by clouds

Additional equipment
81A filter

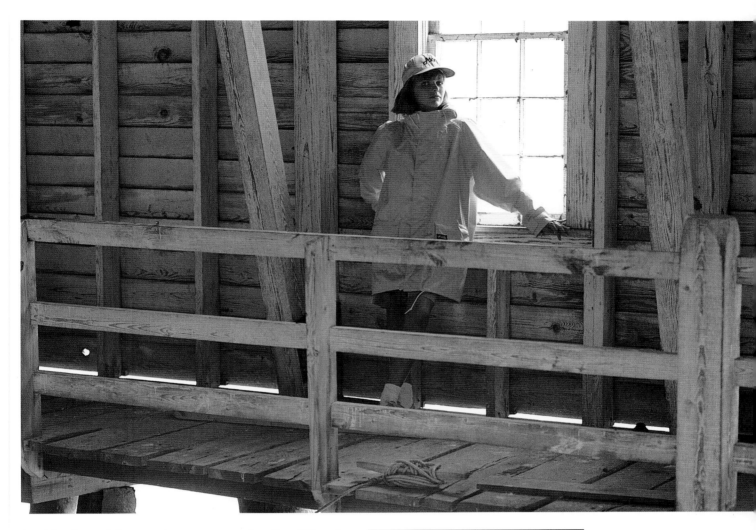

A wide shot of the previous scene, using the diffused skylight coming through the barn windows. To achieve a readable rendering of the interior, use an in-camera meter to measure the light reflected from a section of the wall, ignoring the light filtering through the window. For a more dramatic effect, try metering the light through the window, which will result in a darker overall rendering of the interior.

Photographer
Mike Pocklington

Equipment
Nikon F-3 camera, Nikkor 85mm
f/1.4 lens

Film
Kodachrome 64 Professional

Light
Diffused sunlight

Mixing Light Sources

When the location is good but the available sunlight is poor, a photographer will often change the light by adding electronic flash—"fill flash"—to the scene. The location for this fashion photograph was appealing, but the day was cold and gray, so photographer Scott Sheffield created a sunnier look by positioning a portable studio electronic flash system outside the gateway arch. Two flash heads were used, one covered with a yellow gel to give warmth, the second aimed at a white umbrella to produce an even, diffused bounce light.

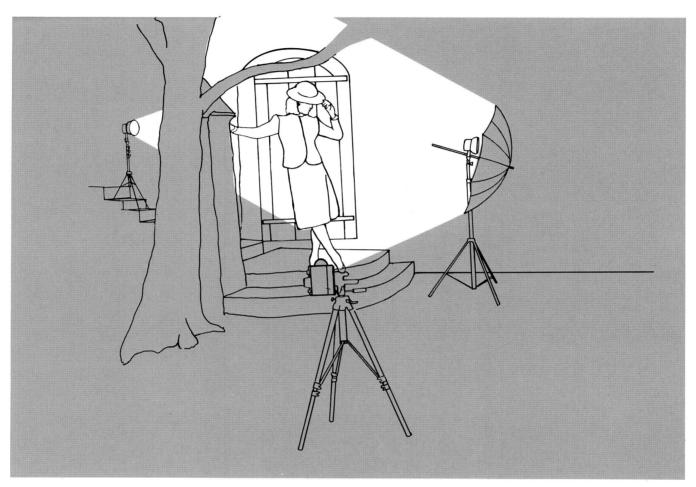

Photographer
Scott Sheffield

Equipment
Nikon F-3 camera, Nikkor 85mm
f/1.4 lens

Film
Ektachrome 64 Professional

Light
Diffused sunlight combined with electronic flash

Additional equipment
Novatron 1000 Plus Power Pack

Mixing Light Sources

The discovery of a setting like this charming antique shop can be a photographer's dream and a location scout's pride. However, lighting it can be difficult.

Photographer Scott Sheffield had to solve three problems in this situation. The client wanted a warm, personable image that focused on the couple and their "find." In addition, the entire shop and its contents had to be well illuminated. To make this all the more difficult, large windows directly behind the camera filled the room with bright sunlight, completely washing out the scene.

Scott overcame the existing light with only 2000 watt-seconds of power, which not only provided two more *f*-stops of light than the sun, but also gave him a more consistent and controllable Kelvin temperature. A silver umbrella was used as a main light source, directed toward the models and brought in as close to the subjects as the live image area would allow. A warming gel was placed over the flash head. The specular quality of the silver made the models appear "hotter" than the rest of the room.

A large white umbrella provided general fill light, and was placed at a greater distance from the models than the silver. The white reflector produced a softer, but less efficient, light source, providing fill for the subjects without overpowering the main light. Finally, a Soft Head, used as a "rim" light, was placed to the right and rear of the female model. The Soft Head, with its yellow gel, added dimension to the subjects, separating them from the background. This rim lighting also added a warming effect that suits the mood of a couple spending an afternoon "antiquing."

Photographer
Scott Sheffield

Equipment
Sinar P 4 × 5 camera, 90mm *f*/5.6 lens

Lighting
Two Novatron 1000 Plus Power Packs, one 52″ white umbrella with 1000 w/s standard head, one 52″ silver umbrella with 1000 w/s standard head with salmon-colored gel, one 16″ soft head with barn doors and yellow gel

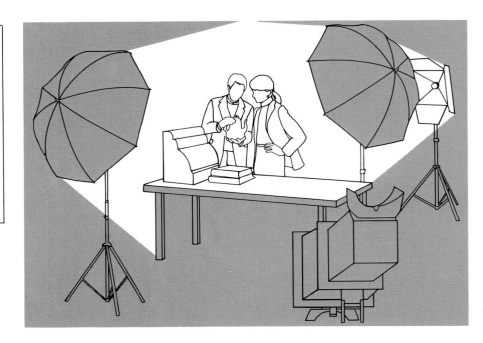

Working With One Light

Experienced photographers "build" their lighting setups, starting with a single light source and observing the visual effect on the model as the light is moved or modified by adding reflectors or diffusion panels. After the first lighting problem is solved, a second light or reflector can be added to further modify the light. The process is continued until the final lighting result has been achieved.

This series of photographs illustrates the different visual effects that can be achieved using a single light—with and without reflectors—placed at different positions around the model.

Photographer
Mike Pocklington

Equipment
Nikon F-3, Nikkor 75–150mm f/3.5 zoom lens

Film
Kodachrome 64 Professional

Lighting
One Novatron 1000 Plus Power Pack, one standard head, 60″ white umbrella, silver and white Flexfill reflectors

In each example shown here, the main light source was a Novatron standard flash head bounced into a 60″ white umbrella. The standard head disperses light at 80 degrees, and the large umbrella's interior surface further softens the light. The first three images shown on these pages show the affect of that one light, there are no supplemental reflectors in use. As the umbrella moves from camera left to camera right, the model is rendered in some harsh lighting situations. Highlights direct attention to facial sheen, deeper pores, and rougher skin texture. Shadow areas dramatize less-than-perfect features and a lack of facial symmetry. All of these effects may be judged too cruel for this face, while they might be considered excellent "character" lighting positions for older faces.

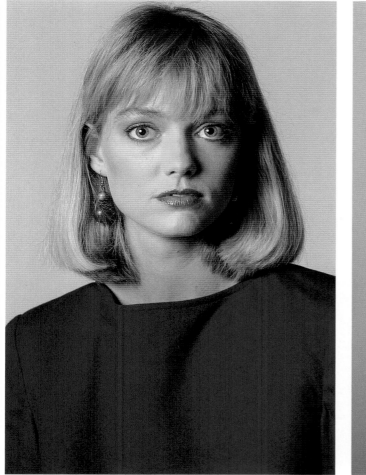

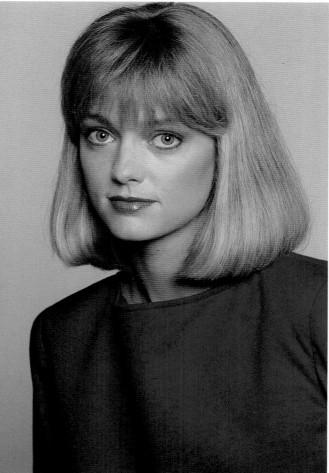

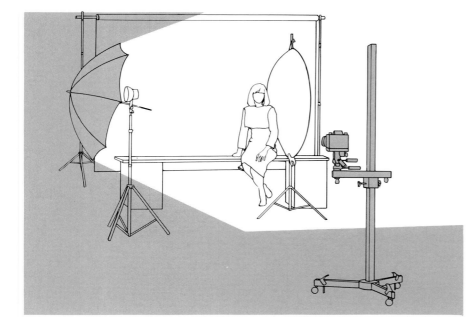

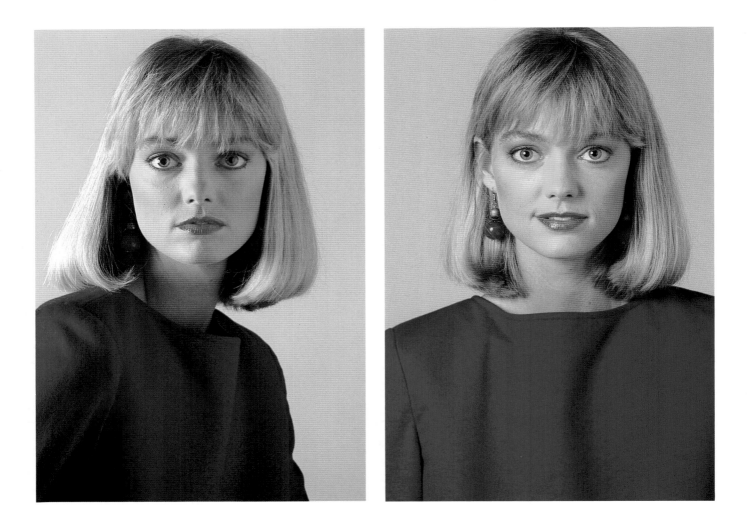

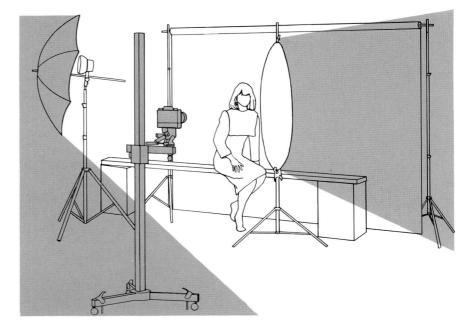

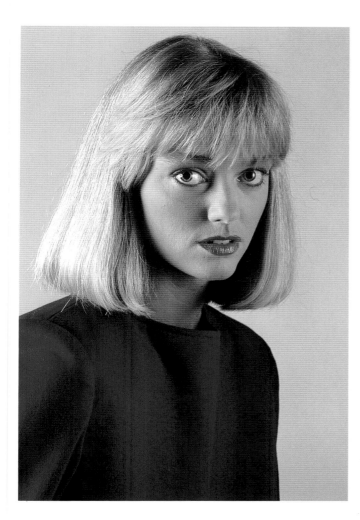 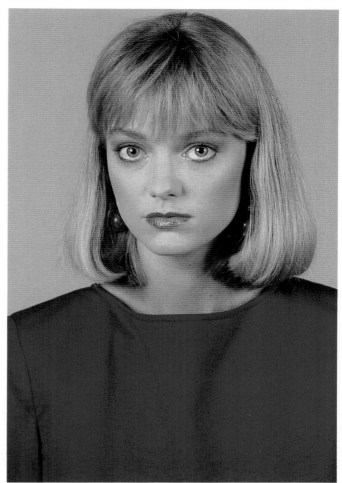

For the two photographs shown on the opposite page, a white Flexfill reflector has been added to the set, to the right of the model's face. This reflector could be said to be a second light source, or *fill* source for the main light. The results are more natural and pleasing. Deeper shadows are now filled with light. The special highlights are now countered and softened. Again, the main light source moves from camera left to camera right, with the image at right on the opposite page probably considered to be the most pleasing, due to the affect of the reflector and its relation to the main light.

In the two photographs shown above, a silver reflector has replaced the white one. The silver surface has a greater efficiency and reflects more light than the white. The white reflector warms the quality of the light it reflects, while the silver bounces back light of almost the same quality it receives. The result is increased spectral highlights on the face and harder edged details.

Working With One Light

Two white Flexfill reflectors have been used in the lighting setup for this photograph, one placed on either side of the model's face. This situation reflects the softest light onto the subject. The transfer area between the highlight and the normal exposure is very broad, as is the transfer from the norm into shadow. The result is a more flattering lighting situation, with no harsh details on the facial surface.

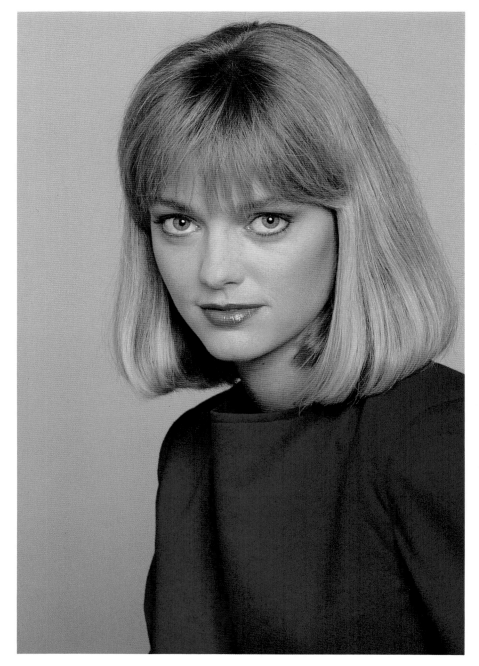

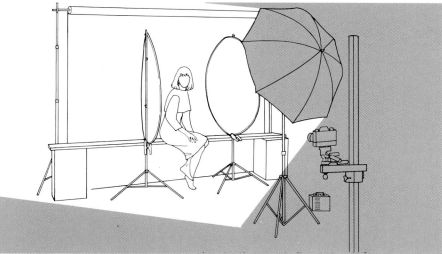

Sculpting With Sidelight

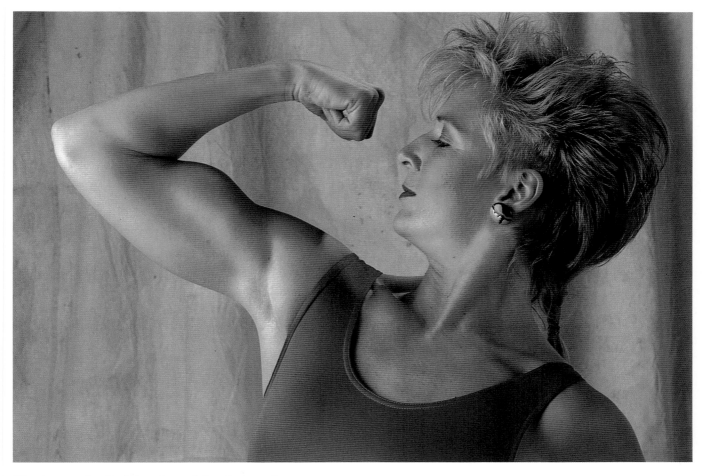

The bare-tube flash head used for the previous photograph is again employed here. In this shot, the light was modified by placing the tube within a large (54″ × 72″) diffusion box, set to the left of the camera and on the same plane as the model. The result is a soft, enveloping light which sculpts the model's body while providing light, open shadows. To further soften the illumination and lighten the shadows, two sheets of white Fomecore board were placed to the right of the camera.

A diffusion box, or "soft-light bank," is one of the most popular light-modifying devices used by photographers. Diffusion banks can range from lightweight, home-made Fomecore boxes to expensive, heavy-duty steel-and-fiberglass structures. To save weight and space, traveling photographers often choose collapsible diffusion boxes constructed of ripstop nylon.

Regardless of the type of construction, the most important part of any diffusion box is the translucent front panel through which the light passes. Popular materials include white Plexiglas or sailcloth, or one of a variety of diffusion materials available from lighting-equipment manufacturers, including Rosco.

Photographer
Mike Pocklington

Equipment
Nikon F-3 with Nikkor 105mm
f/2.5 lens

Film
Kodachrome 64 Professional

Lighting
One Novatron 1000 Plus Power Pack, one bare-bulb flash head, one large 54″ × 72″ Chimera diffusion bank, two Fomecore reflector panels

Additional equipment
An 81A and .025M (magenta) filter used over the camera lens

Sculpting With Sidelight

A good example of a simple, easy-to-adjust setup for sidelighting. The light gives a wide range of highlights and shadows which emphasize the shape and texture of the model's clothes and face.

To supply directional primary illumination, photographer Mike Pocklington set up a single flash head—bounced into a 52 inch diameter white umbrella—to the left of the camera. To further control the primary light, a sheet of Fomecore board was used as a "gobo," blocking a portion of light from the left side of the umbrella. Additional overall illumination was provided by a soft diffusion head, also placed to the left, but farther back from the model. Finally, a sheet of white Fomecore board was placed to the right of the camera to lighten the shadows.

To warm the image, 81A and .025M (magenta) filters were used over the camera lens.

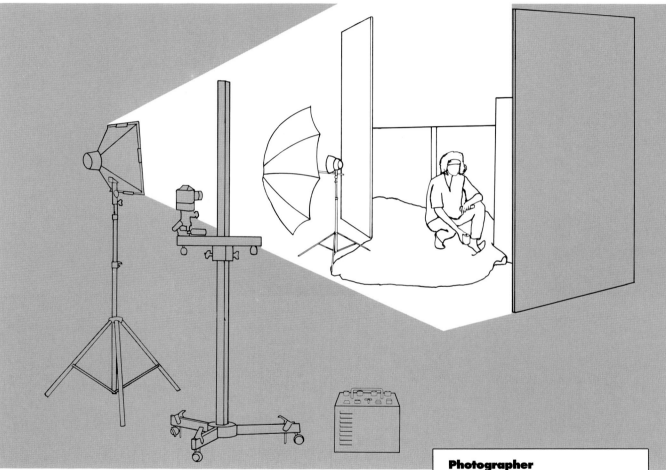

Photographer
Mike Pocklington

Equipment
Nikon F-3, Nikkor 85mm *f*/1.4 lens

Film
Kodachrome 64 Professional

Lighting
One 1000 Plus Novatron Power Pack, one soft diffusion head, one regular flash head, 52″ white umbrella

Additional equipment
81A and .025M filters over the camera lens

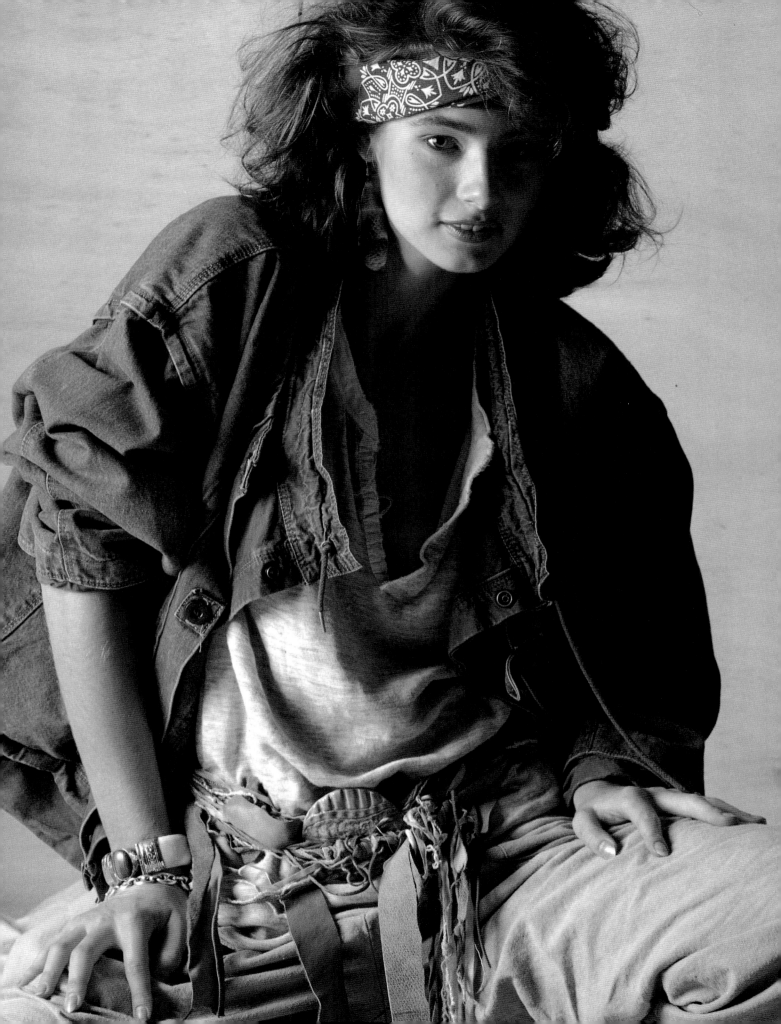

Sculpting With Sidelight

Just because the quality of a bank light's illumination is soft does not mean one can't be used for directional lighting. Bank lights are often positioned close to the side of the camera to achieve specific results. The unique look of this photograph comes from the transitional areas on the model's face between highlight, norm, and shadow. These transitions are soft and gradual because of the highly diffused, directional light source, which seems to wrap the light around the model until it has no choice but to fall into shadow. The model is positioned to face away from the light source and is wearing a black dress, which not only absorbs light, but further enhances the model as her face falls into shadow.

Photographer
Mike Pocklington

Equipment
Nikon F–3 camera, Nikkor 55mm *f*/2.8 Micro lens

Film
Kodachrome 64 Professional

Lighting
One Novatron 1000 Plus Power Pack, one medium Chimera box with 1000 w/s bare-tube head, one 46″ white umbrella

Additional Equipment
An 81A and a .025M filter

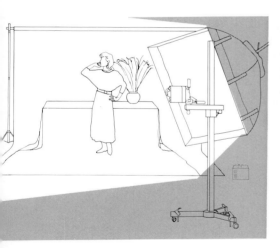

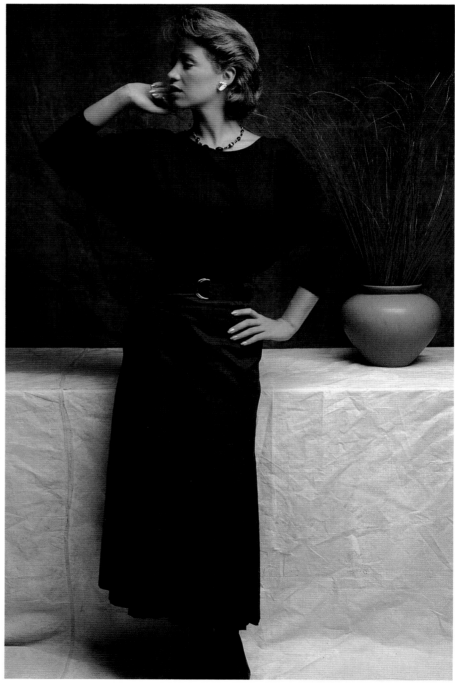

Photographer
Mike Pocklington

Equipment
Nikon F-3, Nikkor 105mm *f*/2.5 lens

Film
Kodachrome 64 Professional

Lighting
One Novatron 1000 Plus Power Pack, one bare-tube flash head, one 4′ × 8′ sheet of white Fomecore

Additional equipment
81A and magenta filters

Sometimes breaking the rules of lighting produces an exciting image. Instead of using a soft diffusion box to eliminate harsh shadows, photographer Mike Pocklington chose to include a sharp-edged shadow as a design element in this shot. A bare-tube flash head without a reflector, placed to the left of the camera, provided a single point source light. The model was positioned close to the background so that his shadow would fall directly behind. The flash tube was adjusted to a point below eye level, so the resulting shadow appears taller than the model. To lighten the dark shadows, a large sheet of white Fomecore was positioned to the right of the camera. In addition, an 81A and a magenta filter were used in combination over the camera lens to warm the model's skin tones.

Sculpting With Sidelight

Sometimes a soft light source is not soft enough. Mike Pocklington wanted the quality of the light in this photograph to be as delicate as his model's features. This effect was achieved by using a studio setup similar to that of an empty room with three white walls. Four soft diffusion flash heads were placed within a custom 40″ × 60″ soft box and hung directly above the model. The "room" was created with four large sheets of lightweight Fomecore. These highly reflective panels put enough bouncing light in motion to result in a beautiful diffusion and a softening of shadow edges.

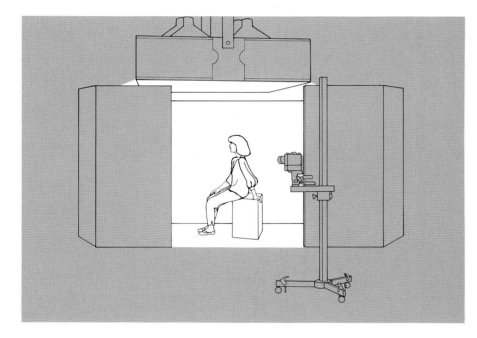

Photographer
Mike Pocklington

Equipment
Nikon F-3, Nikkor 85mm *f*/1.4 lens

Film
Kodachrome 64 Professional

Lighting
Four Novatron 1000 Plus Power Packs, four diffusion flash heads, 40″ × 60″ soft box, four sheets of Fomecore

Additional equipment
An 81A and a .025M (magenta) filter, used with a Nikon #1 soft filter over the camera lens

Simple Lighting Setups

A single light source produces a very natural effect in a photograph. Studio lighting doesn't get any more basic than this setup, which many refer to as "one sun" lighting. One extra-large umbrella was attached to a boom stand and positioned directly over the camera. Diffusion material was draped over the umbrella for an even softer illumination.

Photographer
Mike Pocklington

Equipment
Nikon F–3 camera, Nikkor 85mm
f/1.4 lens

Film
Kodachrome 64 Professional

Lighting
One Novatron 1000 Plus Power Pack, one one-stop head as backlight, 60″ white umbrella with 1000 w/s standard head with Rosco Soft Frost, one white Flexfill reflector

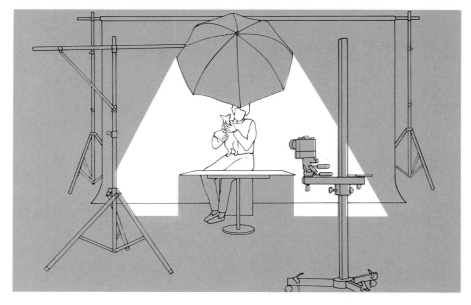

Photographer
Mike Pocklington

Equipment
Nikon F-3 camera, Nikkor 105mm
f/4 Micro lens

Film
Kodachrome 64 Professional

Lighting
One Novatron 1000 Plus Power
Pack, one standard flash head, one
52″ white umbrella, one silver
reflector

When the lighting setup is simple, the photographer
can concentrate on working with the model to create
the best possible picture. For this studio shot, a
single flash head was aimed to bounce light from a
white umbrella positioned directly over the camera.
To add light to the nurse's uniform and the seamless
background, a silver reflector was placed below the
camera, at the model's waist. With the lighting under
control, photographer Mike Pocklington concentrated
on capturing the startled look on the model's face.

Simple Lighting Setups

In both of the images shown here, the photographer has used a variation on the basic one-light setup. A hair light, placed on a boom and bounced into an umbrella, has been placed behind the model to add dimension. Many photographers use a more directional hair light, but Mike Pocklington has chosen a broader source to make a less pronounced visual statement. The model's blonde hair is further separated from the background by focusing a third flash head on the wall behind her. In both cases, the extra attention to the model's hair is an important element in the success of the photograph.

Photographer
Mike Pocklington

Equipment
Nikon F–3 camera, Nikkor
75–150mm *f*/3.5 zoom lens

Film
Kodachrome 64 Professional

Lighting
One Novatron 550 Plus Power
Pack, one two-stop head with gel as
backlight, one one-stop head on
boom as hairlight, one 60″ white
umbrella with 1000 w/s standard
head, one white flat as reflector

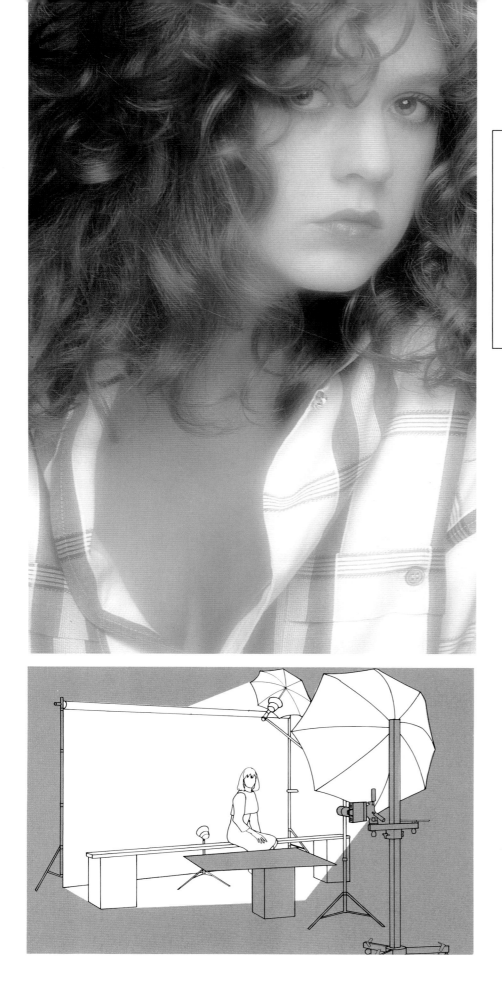

Photographer
Mike Pocklington

Equipment
Nikon F–3 camera, Nikkor
75–150mm *f*/3.5 zoom lens

Film
Kodachrome 64 Professional

Lighting
One Novatron 550 Plus Power
Pack, one two-stop head with gel as
backlight, one one-stop head on
boom as hairlight, one 60″ white
umbrella, one white flat used as
reflector

Lighting for Glamour

The lighting setup demonstrated in this photograph is one used by many nude and glamour photographers. Four Novatron 16″ Soft Heads are fired through a large white diffusion material, known as a *scrim*. The Soft Heads are made of white plastic and spread the light over a wider angle than a standard reflector. The quality of light produced by these unique heads is considerably less harsh than most other reflectors and even greater diffusion results when their light is project through a scrim.

There are a variety of commercial sources for these diffusion materials. Many location photographers prefer to use collapsible, light-weight frames. Some photographers build their own frames, covering them with a relatively well color-corrected material, such as Rosco Soft Frosts. Others who have no concern for the color of their light source, or those preferring a warmer rendition, use any type of cloth, including common bed sheets.

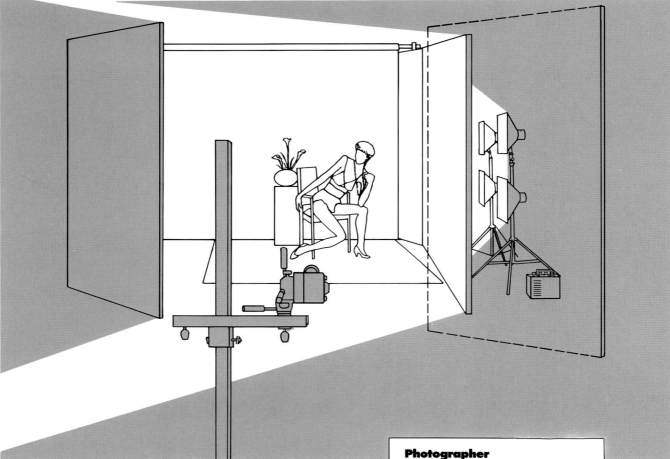

Photographer
Mike Pocklington

Equipment
Nikon F–3 camera, Nikkor 85mm *f*/1.4 lens

Film
Kodachrome 64 Professional

Lighting
Four Novatron 1000 Plus Power Packs, four 1000 w/s 16″ soft heads, two 4′ × 8′ Fomecore panels

Additional Equipment
Nikon #1 soft filter

Lighting for Glamour

In addition to a front light and hair light, the lighting setup for this photograph included a background light to further visually separate the model from the seamless paper. The main light came from a standard flash head bounced into a 60-inch diameter umbrella. The hair light was a one-step reduction flash head hung from a boom to the right of the camera and behind the model, and background illumination came from a two-stop reduction head covered with a blue gel and aimed at the seamless paper. To give a delicate edge to the model's hair and features, a soft filter was used over the camera lens.

Photographer
Mike Pocklington

Equipment
Nikon F-3 camera, Nikkor
75–150mm *f*/3.5 zoom lens

Film
Kodachrome 64 Professional

Lighting
One Novatron 550 Plus Power
Pack, one standard flash head, one
one-stop head, one two-stop head,
60″ white umbrella

Additional equipment
Nikon #1 Soft Filter

To highlight the model's blonde hair, a flash head was placed behind and above the model as a "hair light." Main illumination was provided by a medium (36″ × 48″) diffusion box, placed to the left of the camera, and a white reflector board was positioned under the model's face to lighten the shadows under the nose and eyes.

To achieve a proper balance with the main illumination, the hair light should be set to deliver about one stop less light. If the output is not adjustable, the flash head can be moved away from the model until a one f/stop difference between the main and hair light can be read using a flash meter.

To warm and further soften this image, an 81A, .025M, and #1 soft filter were all used over the camera lens.

Photographer
Mike Pocklington

Equipment
Nikon F-3, Nikkor 105mm f/2.5 lens

Film
Kodachrome 64 Professional

Lighting
One Novatron 1000 Plus Power Pack, one one-stop flash head, one bare-tube flash head in a Chimera medium (36″ × 48″) soft box

Additional equipment
An 81A, .025M (magenta), and Nikon #1 soft filter used over the camera lens

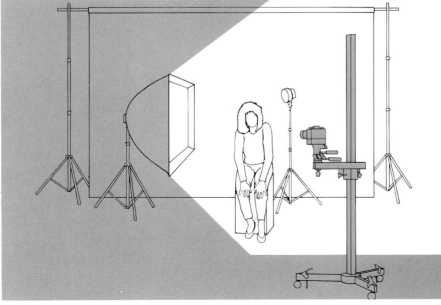

Lighting for Glamour

For some fashion and glamour photographers, a setup of three white umbrellas grouped to the top and sides of the camera is considered standard. Such a setup will not only produce lighting that is very soft and even, it also allows the model a greater degree of body movement than would a single light source combined with reflector panels. This latter situation often requires that a subject hold a precise head and body position for the optimum effect of the setup to be realized.

In the photograph shown here, Mike Pocklington demonstrates the versatility of the three-umbrella setup. One model is positioned behind the other, but both enjoy the same even illumination. There are no harsh shadows under their hair, noses, eyes, and chins, and the transitions between highlights and normal tones are gradual.

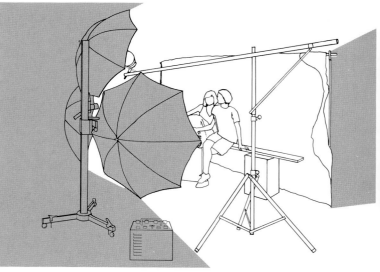

Photographer
Mike Pocklington

Equipment
Nikon F-3, Nikkor 75–150mm *f*/3.5 zoom lens

Film
Kodachrome 64 Professional

Lighting
One Novatron 1000 Plus Power Pack, three standard flash heads, three 52″ white umbrellas

Additional equipment
An 81A and a .025M (magenta) filter used over the camera lens

Many flash manufacturers offer "ring lights," circular flash tubes that provide even illumination, for close-up photography of small objects. On a larger scale, the same type of ring lighting is often used for shadowless "beauty" lighting. For this photograph, three standard flash heads, bounced into three, 52-inch-diameter, white umbrellas, were arranged in a triangle around the camera. The resulting illumination eliminated the shadows commonly seen beneath the eyes and nose when a single overhead light source is used.

Lighting for Glamour

Another method of providing soft, glamorous lighting while maintaining crisp highlight is to use an overhead light bank and a large reflector in front and below the model. For this photograph, four soft diffusion flash heads were placed within a 4′ × 6′ custom soft box.

The box was hung overhead, and a large sheet of white Fomecore was curved upward from underneath the model. To further soften and warm the image, a #1 soft filter, and 81A and .025M (magenta) filters were used over the camera lens.

Photographer
Mike Pocklington

Equipment
Nikon F-3

Film
Kodachrome 64 Professional

Lighting
Four Novatron 1000 Plus Power Packs, four soft diffusion flash heads set in a 4′ × 6′ soft box

Additional equipment
An 81A, .025M (magenta), and Nikon #1 soft filter used over the camera lens

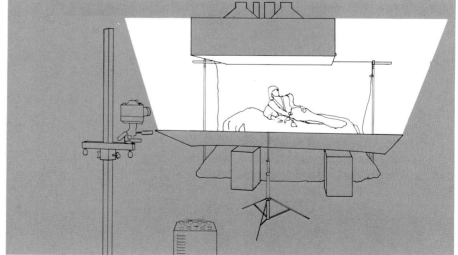

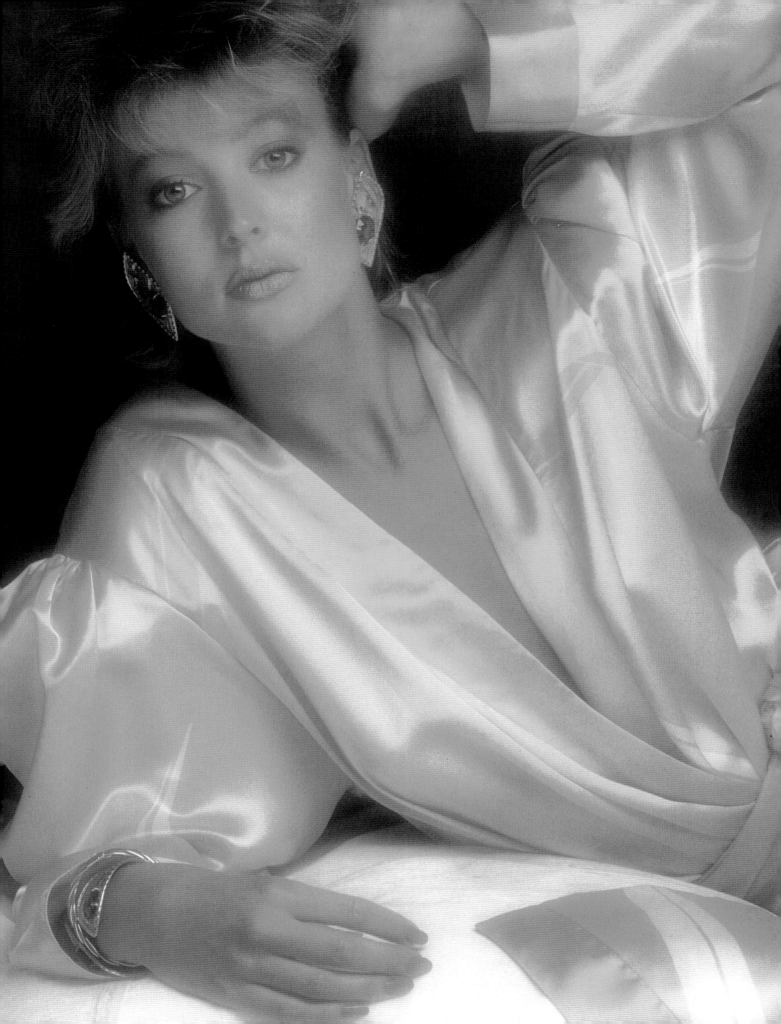

Lighting for Glamour

Light and color are used to separate foreground and background in this complex studio setup. First, a textured flooring surface was laid on a platform, then a second platform was erected, on which the model reclined. Silver miniblinds were hung in front of white seamless paper, and four soft diffusion heads were placed below the lower platform. The heads were covered with purple gel material and aimed toward the seamless background paper.

Main illumination came from a four-tube flash head installed in a large banklight hung directly over the model. To further diffuse the light, large Fomecore panels were placed on both sides of the camera.

Photographer
Mike Pocklington

Equipment
Nikon F-3, Nikkor 55mm *f*/2.8
Micro lens

Film
Kodachrome 64 Professional

Lighting
Eight Novatron 1000 Plus Power Packs, four soft diffusion flash heads, one four-tube flash head used in large Chimera soft box, four Fomecore panels

Additional equipment
Purple gels used over four diffusion flash heads

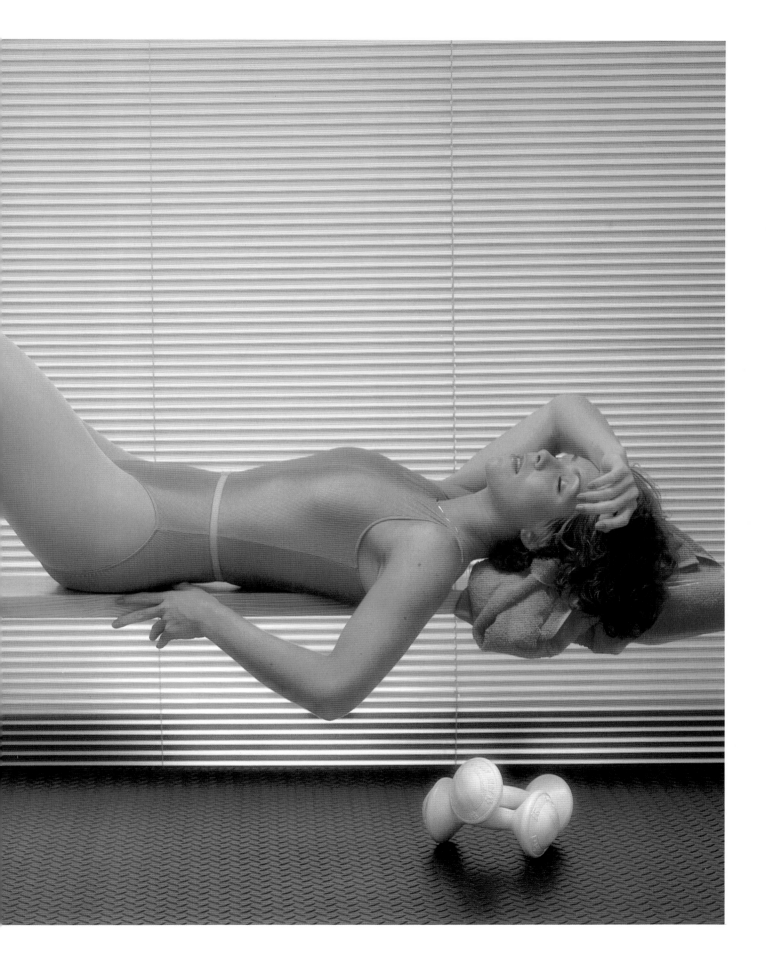

Lighting for Glamour

Lighting is often used to separate the subject from its background. In this photograph, the red background is separately illuminated by a bare-tube flash head placed below the platform and aimed toward the red seamless background paper. A second bare-tube head placed to the right and above the camera crisply illuminates the model, and a third bare-tube head placed behind a translucent reflector to the right of the camera is used to soften the shadows.

Photographer
Mike Pocklington

Equipment
Nikon F-3, Nikkor 75–150mm f/3.5 zoom lens

Film
Kodachrome 64 Professional

Lighting
One Novatron 1000 Plus Power Pack, three bare-tube flash heads, one Flexfill translucent reflector

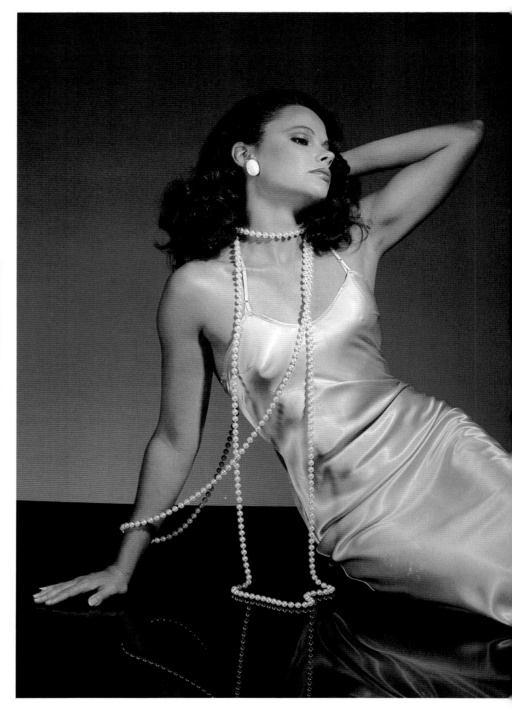

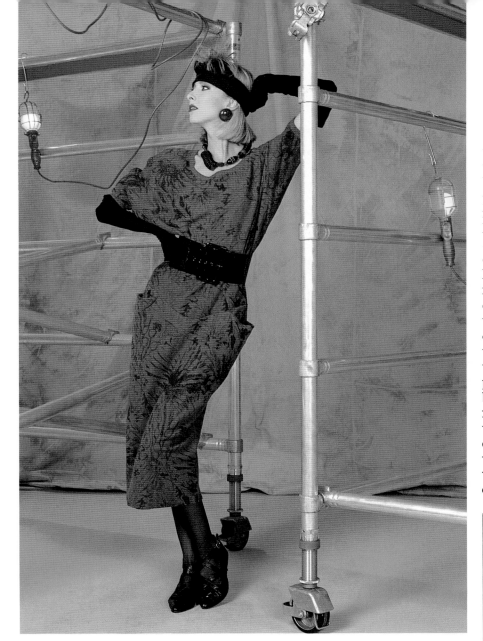

Flash heads covered with red gels were used here to add color to a white canvas backdrop. Careful balancing of the flash head output preserved the red background illumination while providing full lighting of the model. A 4′ × 6′ soft diffusion box containing a quad-head was positioned to the left of the camera to provide main illumination. A smaller diffusion box enclosing one bare-tube flash head was placed to the right of the camera to add additional light, and two bare-tube flash heads, covered with red gel material, were positioned to throw red light on the background. To record the light from the tungsten bulbs in the worklights, the studio was darkened and the camera shutter was opened, then the flash units were fired and the shutter was closed.

Photographer
Mike Pocklington

Equipment
Nikon F-3 camera, Nikkor 85mm *f*/1.4 lens

Film
Kodachrome 64 Professional

Lighting
Five Novatron 1000 Plus Power Packs, 4′ × 6′ diffusion box with four bare-tube flash heads, one medium Chimera diffusion box with one single bare-tube flash head, two bare-tube flash heads covered with red gel

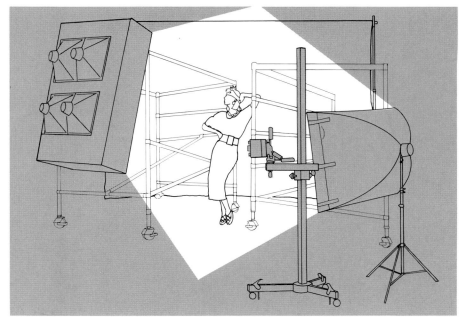

Recreating Natural Light

Flash illumination and tungsten light can often be combined with excellent results. For this location shot, photographer Scott Sheffield set up a soft diffusion flash head to the right of the camera as the source of main illumination. A second flash head, placed to the left of the camera and bounced into a 52-inch-diameter white umbrella, was used to throw additional light on the models. To illuminate the building in the background, three soft diffusion flash heads were placed high on stands to the right of the camera.

An initial exposure was made using the flash illumination, then a second exposure of three minutes was made to record the tungsten lights of the building. Daylight-balanced film was used, so the tungsten bulbs appear very warm yellow-orange.

Technically, this is an *extended* rather than a multiple exposure. The technique used is often referred to as "dragging a shutter." The aperture is determined by the flash exposure, with a flash duration of approximately 1/700th sec. Once the flash has popped, the shutter remains open at the "B" setting. The shutter is closed after an exposure of three minutes, allowing the existing light portion of the image to "burn in." A cable release is essential for exposures of this length to avoid camera shake.

Photographer
Scott Sheffield

Equipment
Nikon F-3 camera, Nikkor 24mm *f*/2 lens

Film
Ektachrome 64 Professional

Lighting
Two Novatron 1000 Plus Power Packs, one standard flash head, four soft diffusion heads, one 52" white umbrella

Recreating Natural Light

Contrasty, hard-edged studio light is used in this image to imitate daylight. The main lighting was provided by a bare-tube flash head in a diffusion box, placed directly in front and above the fisherman. A second flash head was positioned to the right of the camera to simulate sunlight filtering through the window frame constructed in the studio.

Photographer
Mike Pocklington

Equipment
Nikon F–3 camera, Nikkor 75–150mm *f*/3.5 zoom lens

Lighting
Four Novatron 1000 Plus Power Packs, one medium Chimera box with 1000 w/s bare tube head

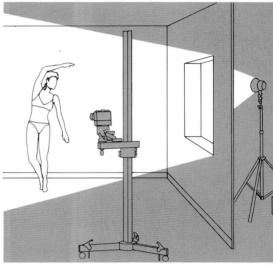

Photographer
Mike Pocklington

Equipment
Nikon F-3, Nikkor 85mm *f*/1.4 lens

Film
Kodachrome 64 Professional

Lighting
One Novatron 1000 Plus Power
Pack, one standard flash head.

Additional equipment
Yellow-orange gel used over the
flash head, 81A filter used over the
camera lens

Mike Pocklington used a single light source in the
studio to recreate the illumination often found in a
natural setting, that of early evening sunlight filtering
through a window. An amber gel was placed over the
main light, which was aimed through a constructed
window on the set. To further warm the quality of
the light, an 81A filter was used over the camera
lens. The result is a controllable imitation of natural
lighting, the warmth of which enhances the overall
mood of the studio situation.

Recreating Natural Light

Proven lighting principles should be adapted with fresh techniques—the result is often more dynamic photographs. Mike Pocklington moved his main light source, a standard flash head, to the far rear side of his subject. This developed a strong series of highlights, almost bordering on a backlit effect. A soft white umbrella was moved to the front position most photographers use for the main light source. This reverse-positioning of main light and fill provided the actor-model with a very strong, masculine image.

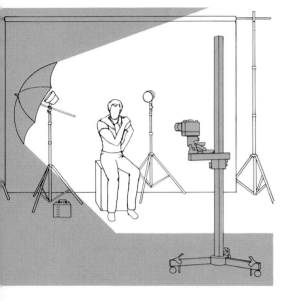

Photographer
Mike Pocklington

Equipment
Nikon F–3 camera, Nikkor 105mm f/2.5 lens

Film
Kodachrome 64 Professional

Lighting
One Novatron 1000 Plus Power Pack, one 1000 w/s bare-tube head, one 46″ white umbrella

Photographer
Mike Pocklington

Equipment
Nikon F-3 camera, Nikkor 85mm
f/1.4 lens

Film
Kodachrome 64 Professional

Lighting
Four Novatron 1000 Plus Power
Packs, four 16″ soft-head flash tubes
inside a 4′ × 6′ diffusion box, gobo

Additional equipment
An 81A filter used over the lens to
warm the image, and a smoke
machine to create the haze

The strong, directional sidelighting of late afternoon
sunlight is re-created here in the studio. A 4′ × 6′
diffusion box containing four 16″ soft flash heads was
positioned vertically to the right of, and at the same
height as, the camera. A sheet of Fomecore board
was positioned behind the diffusion box, to act as a
light-blocking "gobo," and to prevent the spill of light
from striking the black background. Finally, a smoke
machine was used to generate a haze near the light
source.

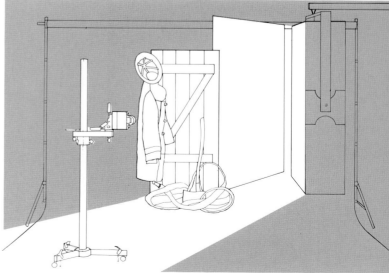

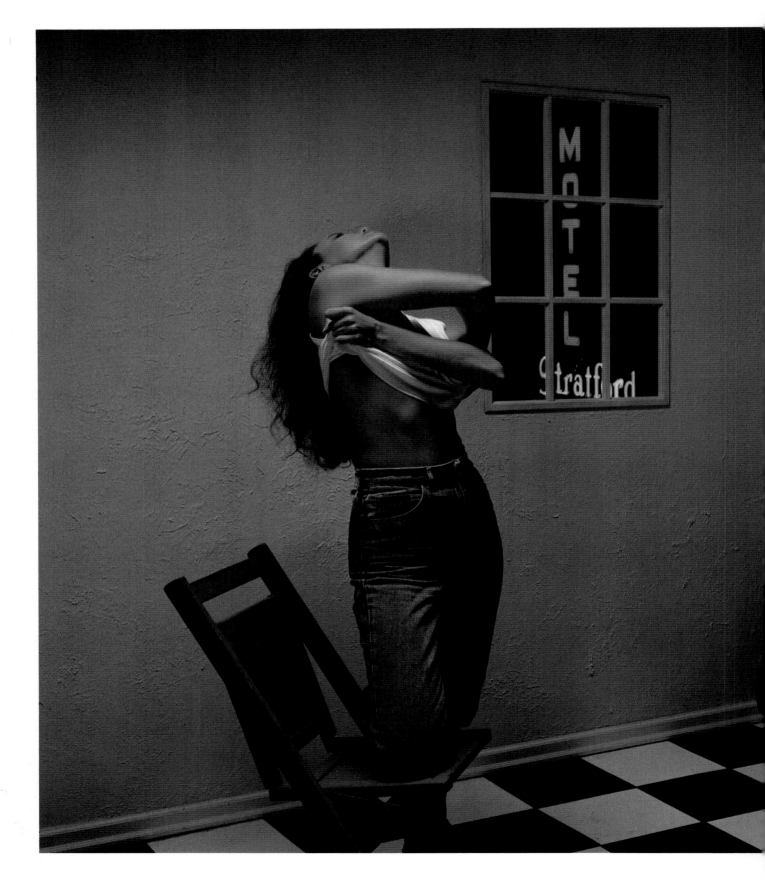

What looks to be an available-light photograph taken in a motel room is really a carefully lit studio image made against a two-wall set. Electronic flash was used, with an overhead diffusion box providing the main lighting. A second flash head was placed to the left of the camera, with the light diffused through a cloth screen. The light of a flash, shaped to a narrow beam with the aid of a four-blade barn-door attachment, added illumination to the right of the camera. Finally, a bare-tube flash in a customized projector was used to throw a beam of red light through the window frame from behind the set wall.

An initial exposure was made with electronic flash illumination, then, with the studio dark, a second exposure was made on the same frame for the motel sign, which was actually a 35mm slide projected on a white wall. The second exposure was for six minutes, and an 80A color conversion filter was placed over the projector lens to change the 3,400° Kelvin color temperature of the projector light to 5,500°K, matching the daylight film in the camera.

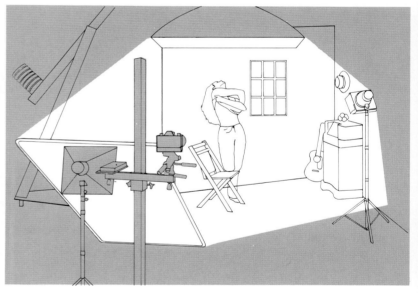

Photographer
Scott Sheffield

Equipment
Nikon F-3

Film
Ektachrome 64 Professional

Lighting
Three Novatron 1000 Plus Power Packs, four heads, Chimera diffusion box, beam projector, diffusion screen, four-way barn doors

Creative Effects

Although this photographs breaks some of the "standard" rules of photography, the image remains visually appealing. The predominant colors are the black and white of the tile floor, the chair, and the model's dress—not the usual subject for a color photograph. But by adding a rolled swatch of seamless paper to the background, the image comes alive with a red accent. Tilting the camera from its normal horizontal axis adds a dramatic twist.

A large diffusion box containing a bare-tube bulb was used as the single source of illumination from the left of the camera. To warm and soften the image, an 81A, .025M, and #1 soft filter were used over the camera lens.

Photographer
Mike Pocklington

Equipment
Nikon F-3 camera, Nikkor 55mm *f*/2.8 Micro lens

Film
Kodachrome 64 Professional

Lighting
One Novatron 1000 Plus Power Pack, large Chimera diffusion box with bare-tube bulb

Additional Equipment
An 81A filter, .025M (magenta) filter, and Nikon #1 soft filter were used over the camera lens.

Creative placement of a light source can result in photographs with unique visual elements that will capture the attention of the most passive viewer. To produce this striking image, a soft box was placed low in front of the model, creating a large shadow on the background. Because of the diffused quality of the light, the shadow edges are not as acute or distracting as those produced by a standard flash head or bare tube. Additionally, the transition from normal tone to shadow area is gradual, both on the model and on the background.

Photographer
Mike Pocklington

Equipment
Nikon F–3 camera, Nikkor 85mm *f*/1.4 lens

Film
Kodachrome 64 Professional

Lighting
One Novatron 1000 Plus Power Pack, one 1000 w/s bare-tube head, one medium Chimera soft box with 1000 w/s bare-tube head

Additional Equipment
An 81A, a .025M, and a Nikon #1 Soft filter

Creative Effects

For this photograph, the model was seated on a platform in front of a large sheet of pegboard. Yellow seamless paper was hung behind the pegboard, and four flash heads—two on stands, two on the floor—were covered with yellow gel material and aimed to bounce light off the seamless paper and through the pegboard holes. In addition, a white umbrella was placed above the model to reflect light from a fifth flash head. This head, with diffusion reflector, was set to its lowest light-output level, and two sheets of diffusion material were used to further reduce the light.

A special triggering device, sensitive to both motion and sound, was mounted near the camera and used to fire the flash units. Such triggering devices, like the Dale Beam used here, are available from specialty photographic supply houses. The studio was darkened, and when the hose valve was opened, the trigger detected the motion of the water and fired the flash. Because the four generators were electrically linked and set for their lowest light output, the flash duration was a very fast 1/4,000th of a second, which was necessary to freeze the stream of water in midair.

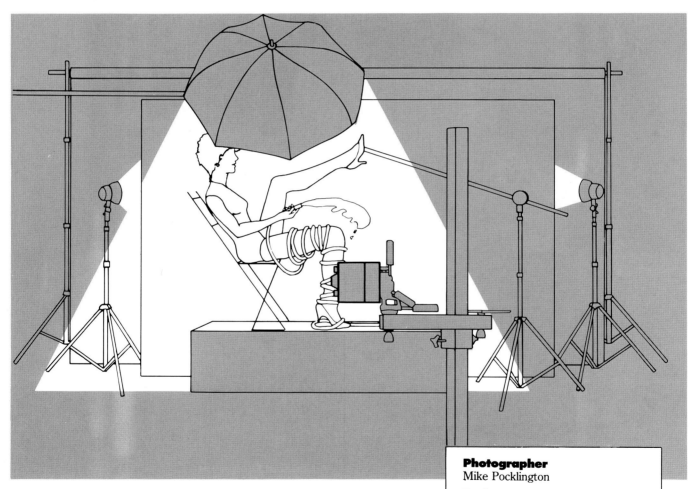

Photographer
Mike Pocklington

Equipment
Nikon F-3 camera, Nikkor 55mm *f*/2.8 Macro lens, triggering device

Film
Kodachrome 64 Professional

Lighting
Four Novatron 1000 Plus Power Packs, 4 standard flash heads with yellow gels, one soft head and white umbrella

Creative Effects

An unusual "special effect" is the use of very warm light sources, such as firelight or a lantern, to create a warm, romantic look. A single kerosene lantern was set up to throw light on the model, and daylight-balanced color film was used to intensify the orange-yellow glow from the lantern. Because of the low level of illumination, a fast lens was required, used at a wide aperture.

Photographer
Scott Sheffield

Equipment
Nikon F-3 camera, Nikkor 85mm
f/1.4 lens

Film
Ektachrome 64 Professional

Lighting
One kerosene lamp

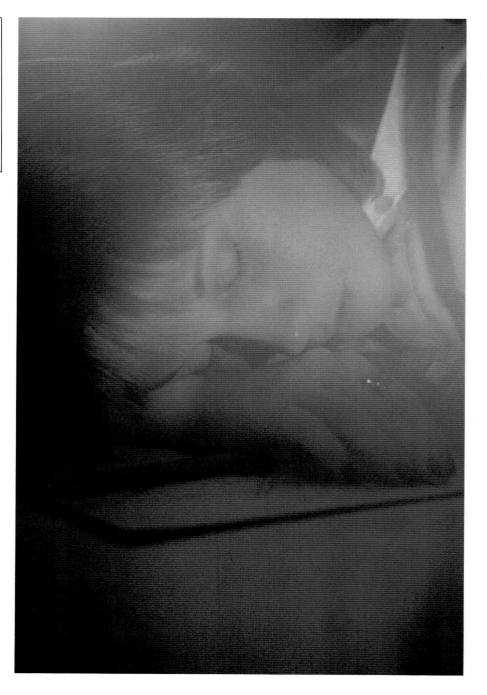

Often, natural sources of light can be used to create interesting special effects with the "wrong" color film. In this tightly cropped photograph of the propane flame from a hot air balloon heater, the warm fire light (about 3000 degrees Kelvin) is recorded in even more lush yellow-red tones on daylight-balanced color transparency film. Also adding to the red color is the early morning sunlight filtering through the red fabric of the balloon.

Photographer
Mike Pocklington

Equipment
Nikon FA, Nikkor 75–105mm *f*/3.5 zoom lens

Film
Kodachrome 64 Professional

Lighting
Early morning sunlight mixed with light from the heater flame

Lighting the Still-Life Set

Excellent food photography demands lighting that wraps itself around every surface of the subject. Food stylist Robin Lutz designed a "Tex-Mex" set that is a classic example of such complexity. Photographer Mike Pocklington employed a single light source to avoid unnatural shadows and used large reflectors to provide natural-looking fill. Very careful placement of the soft box resulted in the visual highlights that focus the attention on the plate in the foreground.

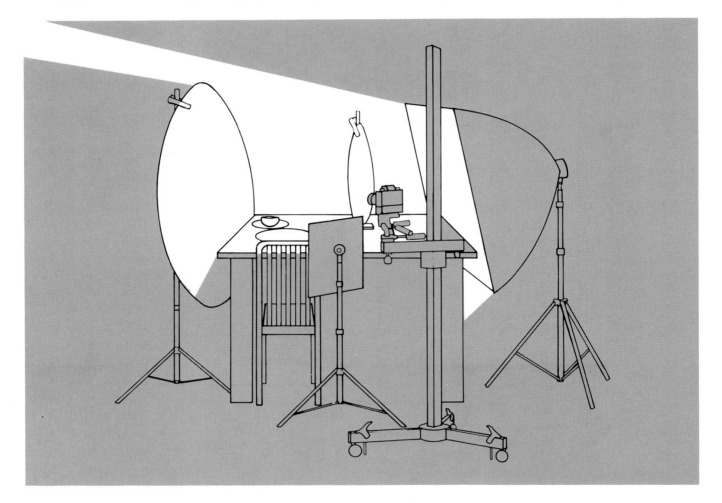

Photographer
Mike Pocklington

Equipment
Nikon F–3 camera, Nikkor 55mm *f*/2.8 Micro lens

Film
Kodachrome 64 Professional

Lighting
Four Novatron 1000 Plus Power Packs, one medium Chimera soft box with one 4000 w/s quad head, one white Flexfill reflector

Still life and food photographers depend upon carefully placed, diffused lighting sources to clearly define, separate, and add texture to the elements of the composition, making them highly "readable" to the viewer. To photograph this shrimp dinner, the camera was positioned above the dish, using a studio camera stand with an extension arm. A single 16" soft flash head was placed behind a translucent diffusion screen to the right of the dish to provide soft sidelighting. To lighten the dark shadows, a sheet of white Fomecore was placed to the left of the dish.

Photographer
Mike Pocklington

Equipment
Nikon F-3 camera, Nikkor 105mm
f/2.8 Micro lens

Film
Kodachrome 64 Professional

Lighting
One Novatron 1000 Plus Power Pack, one 16" soft head, one Flexfill diffusion screen, one Fomecore reflecting panel

Lighting the Still-Life Set

To further enhance the nostalgic mood of the war mementos collection, the photographer included a shaft of light falling across the table, which resembles sunlight streaming through an attic window. To create the shaft of light, two large sheets of Fomecore board were lined up, with a gap of a few inches between the edges of the panels. A bare-tube flash head, covered with a yellow gel, was then placed behind the slit to create the shape of light. Main illumination was supplied by a medium diffusion box containing a quad-head, hung directly over the still-life set.

Photographer
Mike Pocklington

Equipment
Nikon F-3 camera, Nikkor 75–150mm *f*/3.5 zoom lens

Film
Kodachrome 64 Professional

Lighting
Two Novatron 1000 Plus Power Packs, one bare-tube flash head, one medium Chimera diffusion box with a four-tube head, two Fomecore panels used as gobos

Lighting the Still-Life Set

Photographing highly reflective objects, such as jewelry or glassware, requires special precautions to avoid unflattering reflections from the light source. For this picture of glass-faced watches, photographer Scott Sheffield brought the white seamless paper up from the table to form a "tent" through which the light from a 16″ soft flash head was diffused. White reflective panels were placed on each side of the composition to form the walls of the "tent." Finally, additional illumination was provided by a bare-tube flash head installed in a medium diffusion box hung over the watches and at a slight angle. Special care was taken to position all light sources and watches so that undesirable reflections were not visible.

Photographer
Scott Sheffield

Equipment
Sinar p 4″ × 5″ camera, 150mm lens

Film
Ektachrome Professional

Lighting
One Novatron 1000 Plus Power Pack, one 16″ soft diffusion head, one medium Chimera diffusion box with bare-tube flash head, reflective tent and side panels

As with the previous photograph, this image also makes use of a projected image, but with a more elaborate technique. A large sheet of white illustration board was placed behind the perfume bottle, then the image of the sky was thrown on the board from a slide projector. The projector was positioned above the level of the bottle to avoid any interference with the beam of light.

A sheet of translucent white Plexiglas was used for a base for the bottle, with a red-gelled flash head aimed up from underneath the plastic sheet. A second flash head, with the light shaped into a narrow beam by a "snoot" attachment, was aimed at the bottle from directly overhead. Finally, silver reflectors were placed on either side of the bottle, and a small piece of gold cardboard was placed directly behind the bottle to add golden highlights to the glass.

An initial exposure was made using electronic flash, and a second exposure of two minutes—made with the studio lights turned off—was made on the same frame of film in order to capture the projected sky.

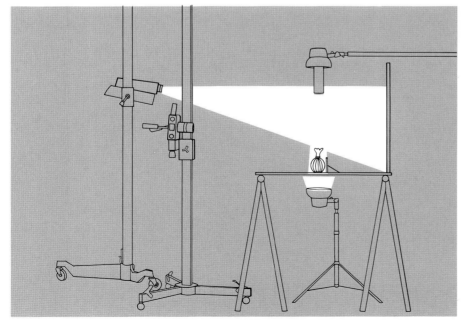

Photographer
Scott Sheffield

Equipment
Nikon F-3, Nikkor 105mm *f*/2.8 Micro lens

Film
Kodak Ektachrome 64 Professional

Lighting
Novatron 1000 Plus Power Pack, standard head, snooted head, silvered reflectors

Lighting the Still-Life Set

In this photograph, the glasses, and the liquid they contained, were made more lively by illuminating them from underneath. A sheet of Plexiglas was used as the horizontal surface, and a 16″ soft diffusion head was placed below the plastic and aimed up. A 4′ × 6′ diffusion box, placed above the camera, provided the main illumination, and a soft diffusion head was aimed at the glasses from just over the camera as a fill light. In addition, two standard heads were used to add a touch of light to each end of the row of bottles in the background. Finally, two large sheets of white reflective Fomecore material were positioned on either side of the camera for additional reflection and soft highlights.

Photographer
Scott Sheffield

Equipment
Sinar p 4″ × 5″ camera, 120 roll film back, 150mm *f*/5.6 lens

Film
Ektachrome 64 Professional

Lighting
Three Novatron 1000 Plus Power Packs, two 16″ soft diffusion heads, one 4′ × 6′ diffusion box containing four standard flash heads, two standard flash heads (one with red gel), two Fomecore reflective panels

Photographer
Mike Pocklington

Equipment
Nikon F–3 camera, Nikkor 85mm
f/1.4 lens

Film
Kodachrome 64 Professional

Lighting
One Novatron 1000 Plus Power
Pack, one 1000 w/s bare-tube head,
fired through white Plexiglas

Milky white Plexiglas can be used as both an excellent diffusion material as well as a shiny reflector for bouncing light. As a reflector, Plexiglas has an advantage over a matte-surfaced reflector card, because its shiny surface offers a greater specularity of light. The image shown here was enhanced by the additional punch of a slightly harder edge, while even, yet directional, light was maintained.

Specialized Lighting Setups

To create a visual feeling of floating in space, the model's white-gloved hands were placed through an opening in a sheet of black velvet. Pink and blue ribbons were attached to the velvet just above the hands to form the "light rays."

As the main source of illumination, a bare-tube head in a diffusion box was placed underneath the hands, with a white card positioned overhead to reflect light. A soft-light flash head, equipped with barn doors and hung overhead, provided a narrow shaft of light to illuminate the ribbons.

Two exposures were made on the same film frame. First, the main light was used to render the hands in sharp focus. Then, the model pulled her hands back through the seamless paper, and a second exposure was made using only the shaft of light falling on the ribbons from the secondary light source. For the second exposure, the lens was twisted to its most out-of-focus position, thereby recording the ribbons as soft, glowing "rays."

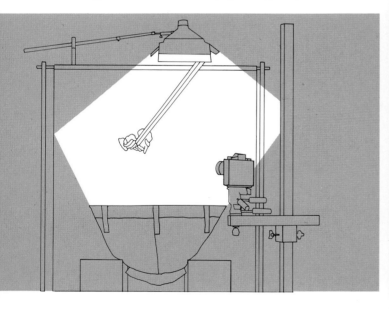

Photographer
Scott Sheffield

Equipment
Nikon F-3 camera, Nikkor 24mm
f/2 lens

Film
Kodak Ektachrome 64 Professional

Lighting
One Novatron 1000 Plus Power Pack, one Novatron 550 Power Pack, Chimera diffusion box with a bare tube flash head, one soft-light diffusion flash head with barn doors

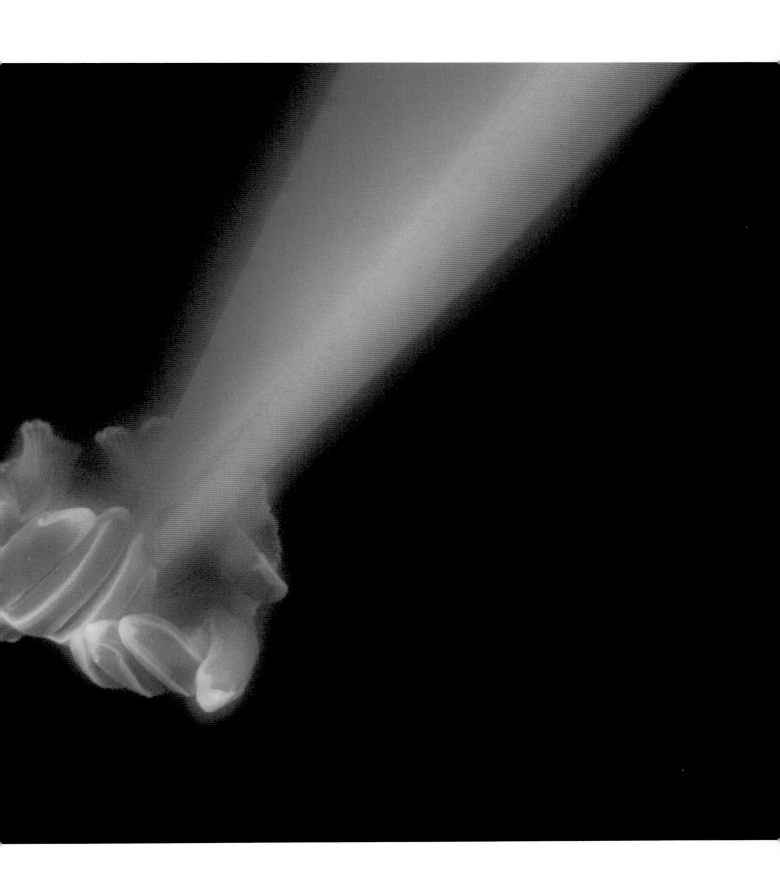

Specialized Lighting Setups

A horizontal shooting surface, constructed of plywood, was covered with a sheet of grid-patterned glossy black Formica and placed in the center of an expanse of black seamless paper. A flash head with a snoot was hung overhead to funnel light onto the control knobs of the equipment. A second flash head in a diffusion reflector was aimed from the right of the camera to provide main lighting of the equipment. A third flash head, equipped with barn doors and covered with a magenta gel, was aimed from overhead toward the top and back edges of the stereo gear. Small pieces of acrylic mirror were strategically placed to reflect light into the controls.

The studio was darkened, and two exposures were made on the same sheet of film. The first exposure, of one-minute duration, recorded the green and red control-panel lights. Then the flash heads were fired to record the main exposure.

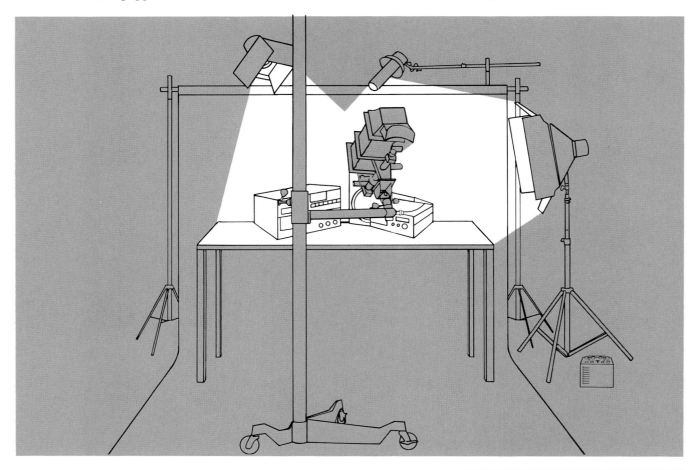

Photographer
Scott Sheffield

Equipment
Sinar P 4 × 5 view camera, 90mm
f/5.6 super Angulon lens

Film
Kodak Ektachrome 64 Professional

Lighting
One Novatron 1000 Plus Power Pack, one flash head with adjustable snoot, one standard flash head with barn doors and magenta gel, one flash head with 16″ diffusion reflector, white Fomecore reflector

Specialized Lighting Setups

Scott Sheffield added mood and interest to this image by using subtle hints of color. Strips of colored gel material were attached to the front of a Chimera box light. Since the area of the box covered by the gels represented only a portion of the source's total output, they did not dramatically contaminate the general color purity of the light. Alternating strips of cyan and magenta gels caused an interesting series of color reflections on the keyboard surface. A fill light highlighted the flower and the smoke, aiding in the proper illumination without overcoming the special effect.

Photographer
Scott Sheffield

Equipment
Nikon F–3 camera, Nikkor 105mm f/2.8 lens

Film
Ektachrome 64 Professional

Lighting
One Novatron 1000 Plus Power Pack, two medium Chimera boxes, each with 1000 w/s bare-tube head, one mirrored panel reflector

A straightforward illustration, made more dynamic with the addition of a drop of "lime juice" at the end of the knife blade. Main illumination came from a bare-tube flash in a diffusion box mounted directly overhead, while highlights were bounced into the scene from a silver reflector positioned underneath the lime. A second silver reflector to the right of the camera highlighted the knife blade.

The lime sections were supported from behind by clear plastic rods run through the seamless paper, while a clamp and lightstand held the knife in position. A generous application of glycerin created the drip effect.

Photographer
Scott Sheffield

Equipment
Nikon F-3 camera, Nikkor 105mm *f*/2.8 Micro lens

Film
Ektachrome 64 Professional

Lighting
Novatron 1000 Plus Power Pack, one standard flash head, Chimera diffusion box

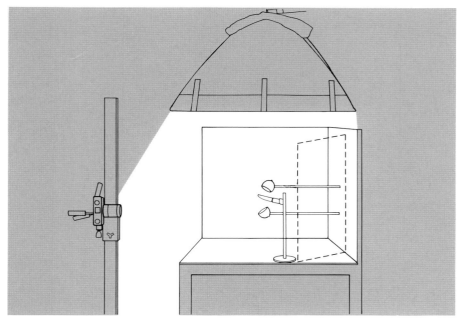

Specialized Lighting Setups

Studio lighting and a double-exposure technique are combined in this photograph of a classic MG automobile. A large, 4′ × 6′ diffusion box containing four soft diffusion flash heads was mounted directly over the automobile, and a 4′ × 8′ sheet of white Fomecore was positioned to the right of the camera in order to add additional light to the radiator grill. An initial exposure was made using flash, then the studio was darkened and the headlights were switched on. A fog machine created a mist in front of the headlights during a two-minute secondary exposure, which was made on the same sheet of film.

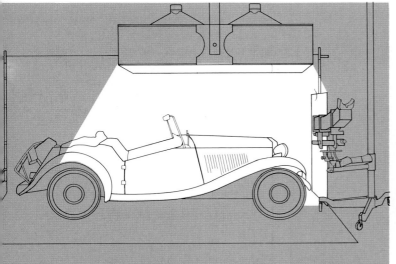

Photographer
Scott Sheffield

Equipment
Sinar P 4 × 5 view camera, 150mm
f/5.6 lens

Film
Kodak Ektachrome 64 sheet film

Lighting
Two Novatron 1000 Plus Power Packs, four soft diffusion flash heads,
4′ × 6′ diffusion box, 4′ × 8′ Fomecore reflective panel

Index